2.7.97.

Dear Martin,
Many post to
be
with love
Jane & Robin.

"The traveller has reached the end of the journey! In freedom of the infinite, he is free from all sorrows, the fetters that bound him are thrown away and the burning fever of life is no more."

'The Buddha' s Teachings'

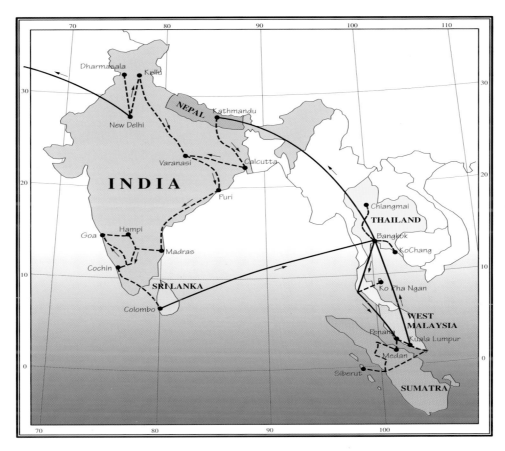

This book really could not have happened without the help of a large number of people. It started out as an idea that was felt to be both interesting and of potential, but in order to make the idea a reality, with the limited resources that were available, we were extremely reliant on many peoples generosity with time, money and professional advice. It would be impossible to try to list everyone who deserves thanks, but a number who helped are mentioned.

— Dans parents, who not only provided a roof and financial support during the last year, but also endless encouragement and a blatant belief in both of us and the product.
— To all those who bought a copy of the book, and invested in the company prior to this being published, again remarkable support.
— People who gave their time to edit, produce, promote and design the book, especially Susannah Walker, Catherine Lowe and Mark Edgington, N R Design, Dan's brothers & sisters and all at Kensington West Productions Ltd.
— All those wonderful people Vicki met and photographed on her travels who were the inspiration for the book.

A big thank you to you all.

VICKI'S FOREWORD

DAN'S FOREWORD

Travelling had always been an ambition of mine. I'd been talking about it for years, but as time went on it got harder to do. Steady job, good prospects and a wage that supported my social life! How could I give it all up? What would I come back to? No job, no money, no home! These thoughts stopped me going. I'd saved enough money, but dropping everything was the hardest part. What if? Always put an obstacle in the way. If I hadn't gone with my heart, I could still be banging my head, wondering what if?, and never knowing! There are many reasons why people don't travel - commitment to work, family and friends or the scary prospect of travelling solo often holds people back. I started my travels with a friend and can so clearly remember the day after we decided to split up. High on a hill top looking down over a vast landscape, thinking about the situation, it suddenly hit me like a brick on the head, I was alone. I was with friends I had recently met, but basically I was on my own. In some ways it was a daunting prospect, but a sudden surge of excitement lifted me up. There was no one to answer to but myself, no one to worry about but myself, there were no more compromises! I was on my own and it felt great! From that day onwards, I can only recall a handful of days that I was alone, that weren't by choice. Meeting people was easier, maybe knowing subconsciously you have to make contact, makes it happen. As a pair or group it is easy to become insular and not make so much of an effort in meeting others.

It's a wonderful feeling being able to share the experiences with a close buddy, but I found it more rewarding travelling alone and meeting a variety of people. Whatever the length of time you are together, you pick up an invaluable wealth of knowledge and discuss different subjects, rather than boring your partner with the same old stories and opinions. Whatever route you choose, your path will cross others' and often several times. It was always a wonderful surprise to meet people again and again, from town to town and even in different countries, but not at all unusual.

When meeting the extraordinary range of people you do, from all walks of life, background and countries, everyone accepts each other as themselves, without judgment or pre-conceived ideas. There is an immediate openness that is shared. The freedom to be yourself and discover yourself is a fundamental aspect of travelling. Whether you are there to explore, relax, learn or escape, there is one united common relationship - your backpack. The majority are eager to hear each others' stories, experiences, dilemmas, advice, beliefs, hopes and dreams.

There are people you don't click with and places you don't like, but the beauty of travelling is having the freedom to move on. There is no right or wrong, fate will lead the way. The coincidences will blow your mind and the experiences will either change your life or just be another chapter in your journal.

I would like to dedicate this book to my sister Jeni.

Like an increasing number of people, I decided to take a year out between school and university, and to use this time travelling. The result? I caught the bug!

In the subsequent six years I have lived, worked and travelled in over forty different countries. Therefore I suppose it was not surprising when a family friend recently challenged me with the question "so what are you going to do with all your travel experience?"

I have always longed to be creative, but at school my art was uninspired and while I loved English sufficiently to take it as one of my A-levels, I only just scraped through - to everyone's amazement! But the desire to be creative never dwindled, in fact time and travel have enhanced it.

Despite having many photos of my own, together with an irregular diary, I had found it difficult to share the experiences and find a common language with family and friends at home. My photos showed amazing scenery, friends I had met, parties and antics that I had got involved in, but an important ingredient was missing. I know this is a common problem with travellers, and Vicki's photos helped solve this problem for me.

For all those fortunate enough to have travelled, for those who have not had the opportunity and for those who need to stay behind and watch friends or their own children disappearing off into a possible unknown, I hope this visual and personal account will provide a similar bridge of communicating and sharing the realities of independent travelling.

CONTENTS

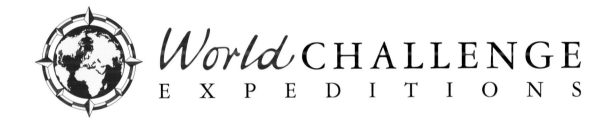

World CHALLENGE
E X P E D I T I O N S

Travellerseye Ltd
30 St Mary's Street
Bridgnorth
Shropshire
WV16 4DW

Tel: 01746 763117

Co-Published By Kensington West Productions Ltd & Travellerseye Ltd.
Text Copyright V.Couchman, D.Hiscocks
Photographs Copyright V.Couchman
Published October 1996

ISBN 1-871349-33-8

Kensington West Productions Ltd
5 Cattle Market
Hexham
Northumberland
NE46 1NJ

Tel: 01434 609933

India

Arrived in Delhi, 12 midnight, Friday 23rd September. Our trip seemed to be going smoothly. We hadn't forgotten anything. It was only as the luggage carousel steadily emptied and my luggage still didn't appear, that anxiety hit me. The endless rotations were starting to make me dizzy. There was no more luggage and mine hadn't arrived. I asked the porter to check again and again, but it was nowhere in sight. This same situation had occurred two years ago in the same airport. That time my luggage never appeared but I was only staying for a couple of weeks, so it hadn't mattered so much; this time I was planning on staying for a year and I found the coincidence hard to deal with. My first thought was that I couldn't survive and I'd have to go home.

I was accustomed to the necessary form filling, but nothing could be done until morning. I left without much hope of retrieving my rucksack. Luckily buses were still running and we hopped aboard for the Main Bazaar. The trip itself was pretty freaky, the pavements and traffic islands were blanketed by people sleeping rough. The bus didn't go to the Main Bazaar, but instead dropped us in the middle of nowhere at 2.30am. A rickshaw immediately picked us up to take us to our destination. He drove through all the cluttered back streets which were dark, still and eerie. A lone figure stepped out from the blackness to stop our rickshaw, telling us there was fighting ahead; the whole situation had a chilling feeling. The rickshaw bombed off in another direction taking us deeper into a warren of tiny streets. In every doorway and unused rickshaw, people were sleeping. We arrived in the Main Bazaar area shaken, but soon found a cheap room. The noise of the humming fan kept us awake most of the night, so we woke still exhausted and with a long day ahead.
I phoned the airport first thing, but alas, no sign of my luggage. The scorching heat was claustrophobic, the dust and the dirt suffocating and the constant badgering from beggars and rickshaw drivers irritating. We took a rickshaw to get out of the hustle and bustle of the city. While we sat in the grounds of Red Fort, we were told by some students that there was an outbreak of the black plague down south. This is where we were heading. What a nightmare! We returned to the hotel to hear some good news from London. My luggage would arrive that evening. Yippie!!!

Before leaving for the airport that evening, we grabbed a cup of coffee in the nearest street cafe and we worked out our plans. While there, we got chatting to some travellers who'd been in India for some time and they told us to head up north. They gave us an address of a woman who would rent a room to us in Kasol. It sounded idyllic, a mountain village with plenty of tradition, away from Delhi and, most importantly away from the black plague. We decided to go there and then.

Despite having had the forms signed by the customs officer to let me back into the airport, I wasn't allowed back. They insisted I needed permission from the airport police. I panicked. The plane was due to land and I wanted to be by the conveyor belt to avoid my rucksack being lost once more in the system. After some time I was able to talk to the chief of police; verbal confirmation that my luggage would arrive wasn't sufficient and he turned my request down. The emotional strain proved too much, down came the flood barriers and on came the tears. Embarrassed looks were exchanged around the room and the chief sighed and stamped my form.

In the event the plane was late. I sat on a trolley by the conveyer belt for an hour. When my backpack finally arrived, I realised how nice it had been without it, for it weighed a ton!

4

HOTEL VISHAL

1. Customer's are requested to take care of their money, pasport and other valueables.

 Deposit your, valueable, cash etc. for safety with the management against proper receipt otherwise responsibilities lie on the coustomers.

2. Room occupants will themselves be responsible for any illegal activities inside the Hotel Premises.

3. Anything objectionable Under Law, such as Heroien, Smake, Hashish, charas, opium etc. should not be in possession of the occupants. Managements is not responsible if occupants have any such item.

4. Check whether the doors & windows of your room are properly locked up before leaving out.

5. Please turn off the Light before leaving room.

6. Check out time 12 Noon.

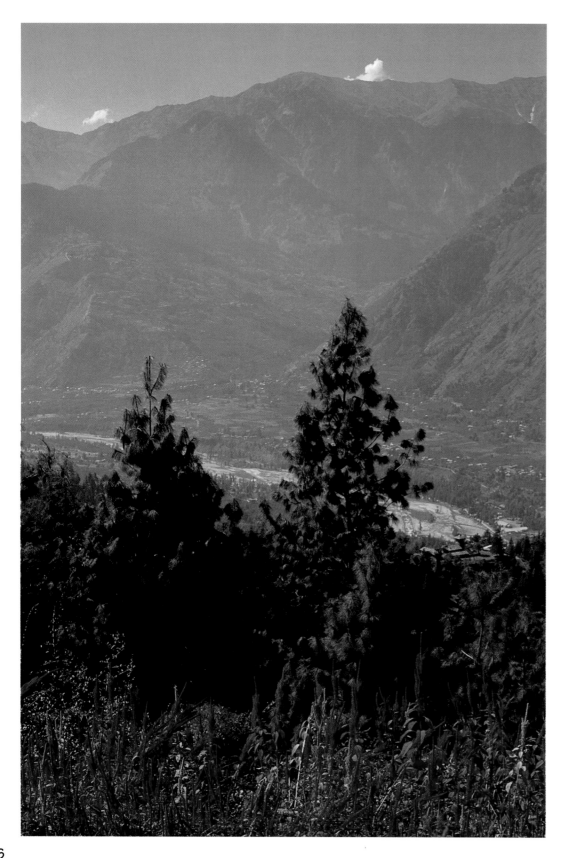

The constant cacophony of vehicle horns kept me awake for the entire thirteen-hour journey to Bhuntar on the night bus from Delhi. The roads became more treacherous as we approached the mountains, speeding through snake like valleys. The driver, silhouetted against the oncoming lights, with a flower-adorned picture of his favoured God above his head, seemed our only hope of survival. The side of the highway was literally a vehicle graveyard. After risking our lives on the night bus, we changed buses to Kasol, and opted for the roof. Apart from having to dodge the overhanging trees, low hanging electricity cables and protruding rock formations, it was the best seat on the bus - spacious, airy and with the chance of escape! On countless occasions we narrowly missed plunging down the cliff edge, and having the option to jump from the bus with our rucksacks was definitely a good one. We beeped our way through flocks of sheep, passed children outside their school house washing their slates clean in a natural spring. Breathing in the crisp morning air, we gasped at the magnificent view.

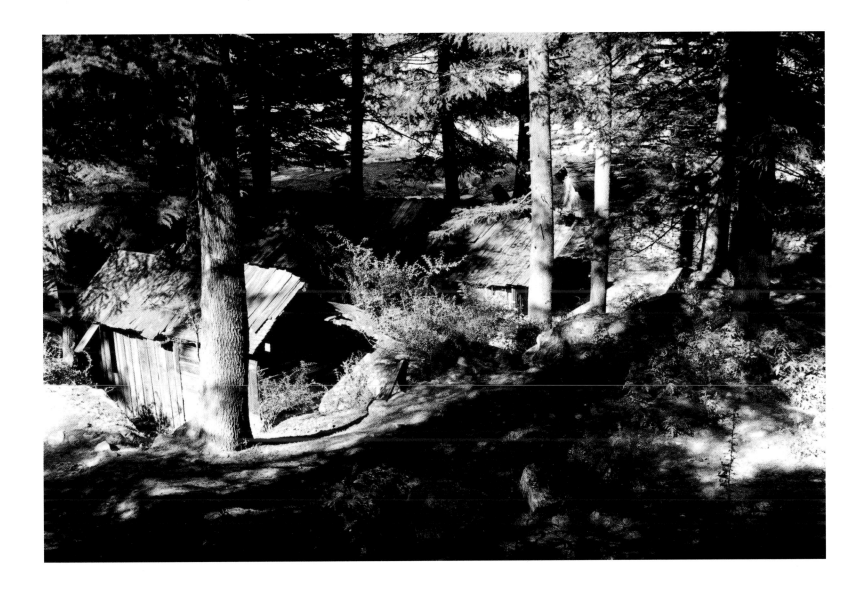

Settling into our new surroundings, the pace of life was slow in comparison to the hectic world we had come from. The rush of the mountain spring flowed behind us, and a sweet chorus of birds and insects filled the air. The huge trees that towered above us shaded the simple wooden shacks from the intense midday sun. We rented a simple room in a farmhouse, with views of the distant snow peaks and smells wafting up from the cows sleeping below.

We had our own Tandoori oven, but the loo was up the garden behind the nearest bush, and the bathroom was further down the valley and over the river at the infamous hot springs. It took us half a day to carry out basic hygienic chores. Home comforts were an age away, forgotten and replaced by the excitement of survival. The peace of this mountain hide-away was a complete release from the pressures and commitments we had left behind.

The basic instinct of survival comes naturally to these mountain folk. They are completely self sufficient. The soil is fertile but the terrain awkward. No-one teaches them, they have to learn the hard way and from a young age.

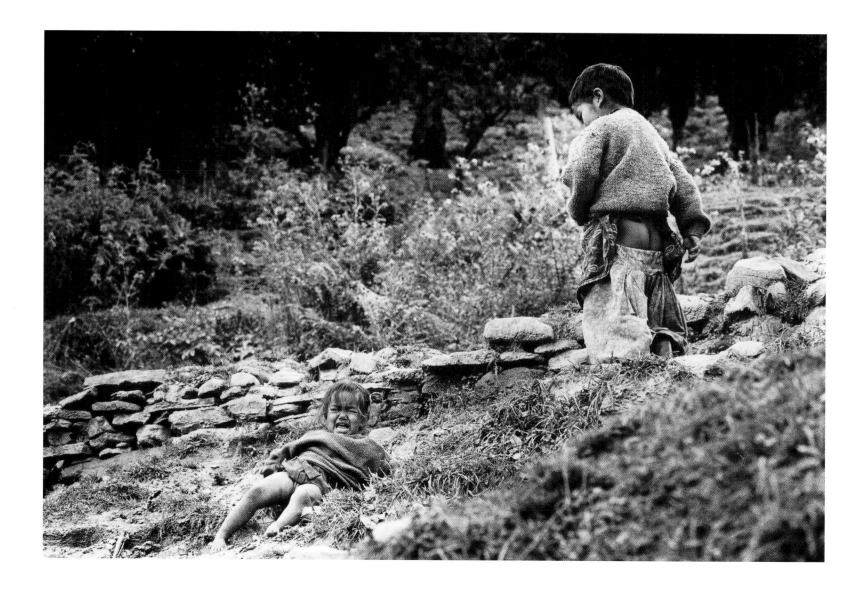

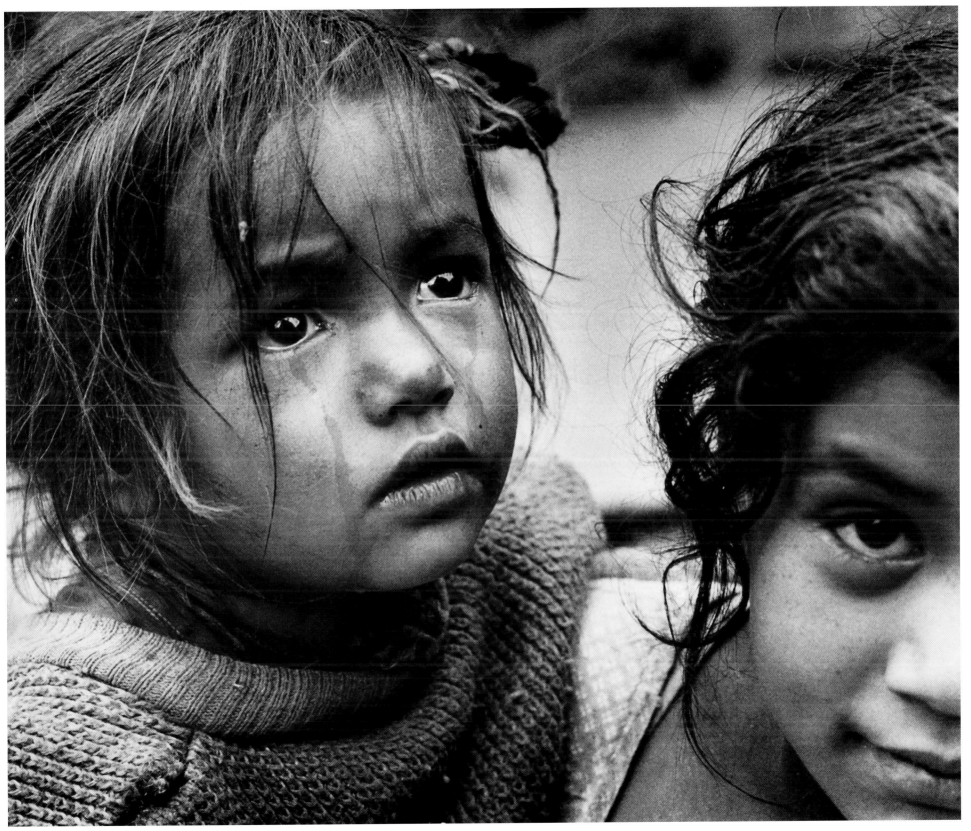

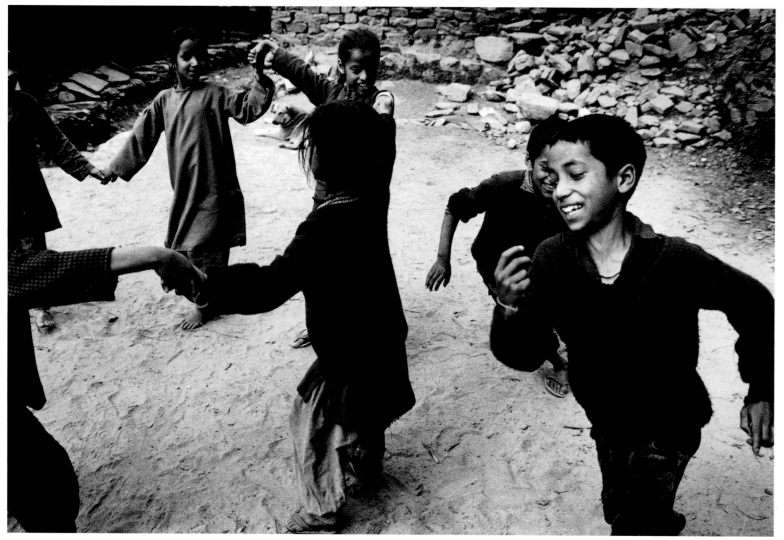

After moving house further up Kullu valley, we decided to climb a nearby mountain. It was, in fact, a hill - but felt like a mountain! We followed a well worn path, past lizards the size of your feet and monkeys playing in the trees. The only sound apart from the insects and animals was our heavy breathing. We got lost on the track, which became less defined and split in several directions. By chance we came across a village of no more than twenty shacks - No cafes, no shops, just peacefully quiet and isolated. As we arrived the village children fled to their hide-outs. Slowly they emerged, but our slightest movement sent them scurrying away shrieking. Gradually they came closer, and before the dust had settled we were shaking hands three times over with each child in the village. The attention we received made us feel famous! Before long, they were carrying on with their games unconcerned by our presence.

After another hundred handshakes, we left the village with the children skipping in a pack behind us. We didn't get far, a hundred yards maybe, when we were stopped in our tracks to 'gawp' at the greenery.

We were surprised to walk into a field full of Marijuana. Whether in the mountains or the city, you won't walk far before "change money, Marijuana" is softly whispered in your ear from a passing stranger.

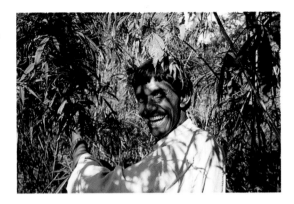

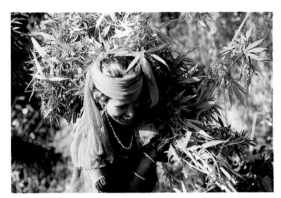

The harvest brings happiness to many.

Many village economies are based on Marijuana.

It's a family affair.

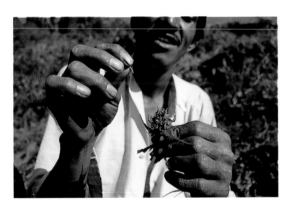

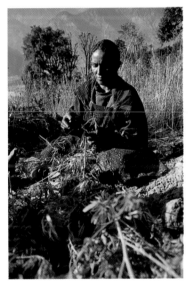

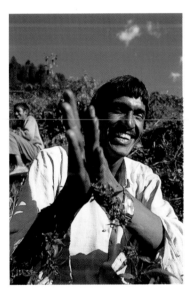

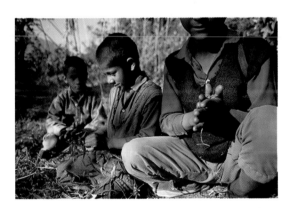

Governments may frown on it, but the Gods approve. For many it is part of their life, religion and culture.

It's fresh, it's pure, it's ready to smoke.

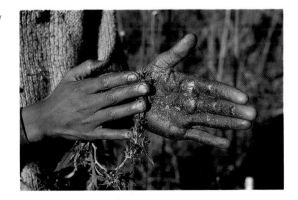

After the harvest, the pace slows down.

11

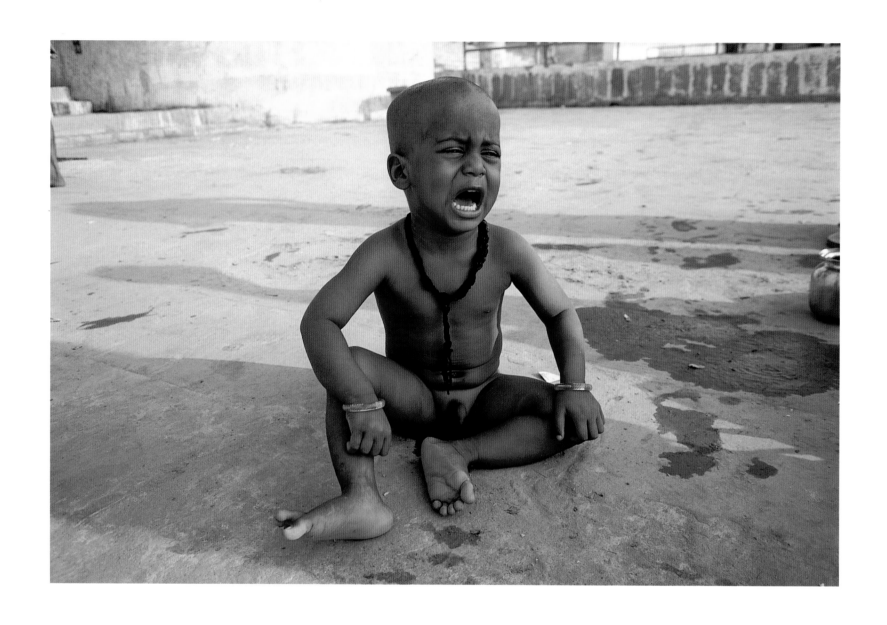

Our travels had only just begun, yet in a relatively short time we had met situations that had moved, shocked and upset us.

Once off the beaten track, our unexpected arrival either attracted curiosity or was upsetting to the locals, seeing Westerners for the first time.

Kept awake all night by the beating of drums, which continued through the morning. We decided to investigate. With permission, we attended the funeral of an old man. Preparations were taking place for his cremation.

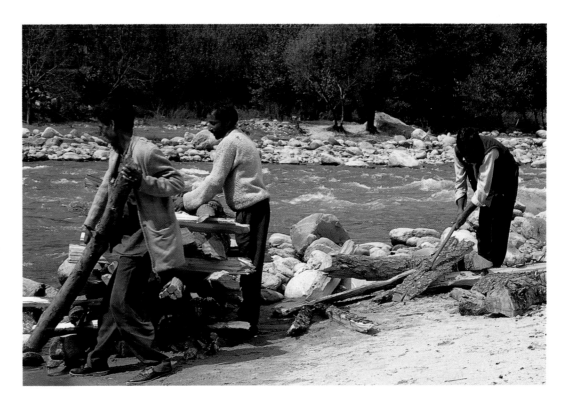

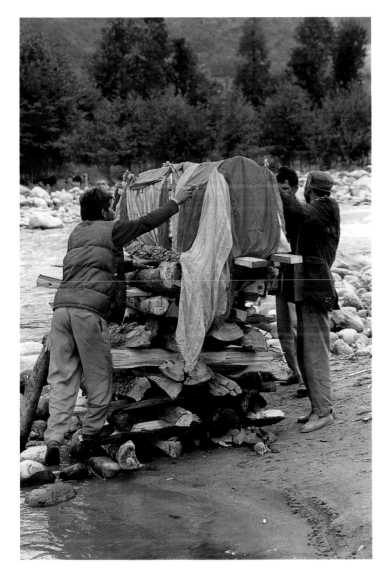

The fire was lit and the body unveiled. The sight of the old man's weathered corpse burning was shocking to us. The women were unable to attend, "because of weak hearts", said a family friend.

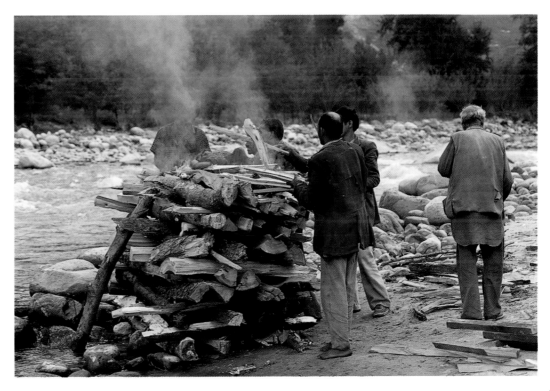

The procession of male family and friends had already made its two hour trek down the mountain to the river's edge. The fire was built and the coffin was laid on top. The group gathered around and the ceremony began.

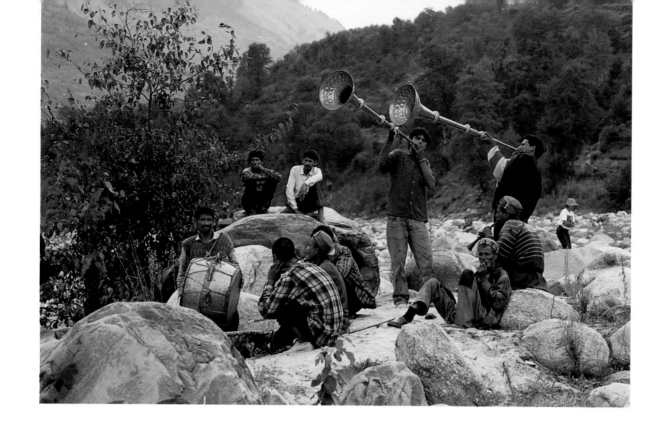

The deafening din from the untuned orchestra added a comic side to the ceremony.

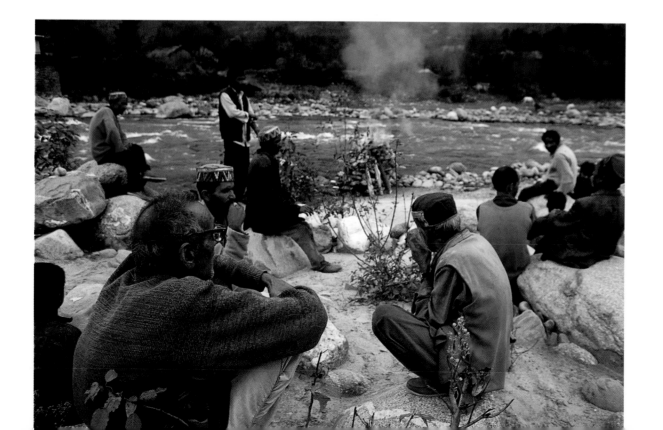

Chatting and smoking, the men seemed oblivious to the spiritual ceremony taking place. We decided to leave when the wind changed direction and the smell of burning flesh wafted our way.

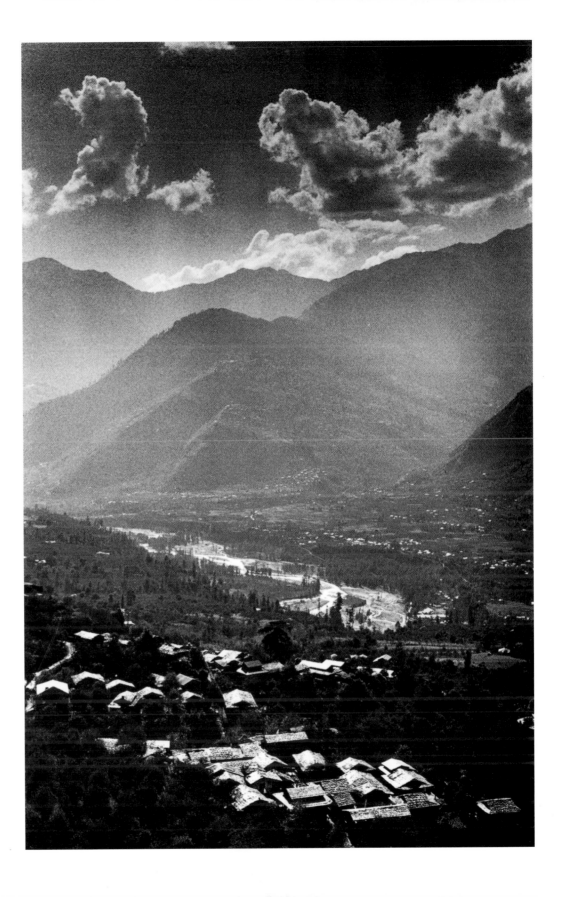

The reality of not having to go back to work was a surprisingly strange feeling to get used to. We began to feel guilty and that it was time to move on. We were enjoying life at this relaxing pace, but felt we should be doing more than just waking up each day and admiring the mountain views.

We passed through Kullu Town, where by chance an important festival was taking place. Hoping to soak up the festival fever we 'hung out', but were overwhelmed by the hoards of tourists, both Western and Indian. The tacky goods for sale and the fairground that should have been condemned a decade before.

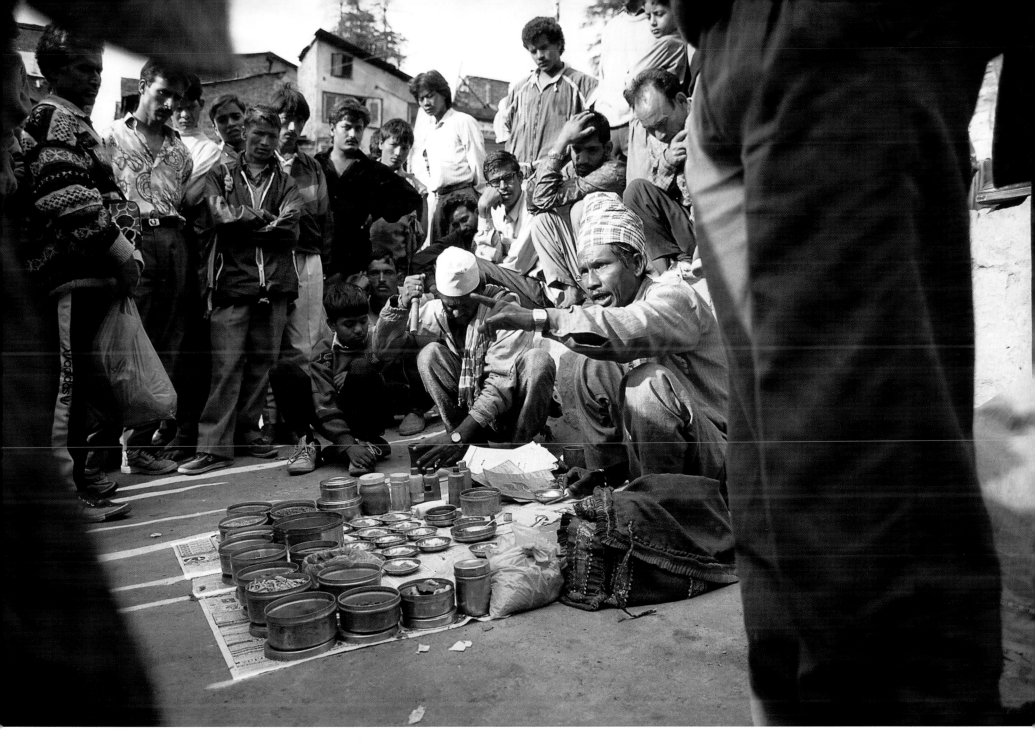

While waiting at a bus stand, a crowd began to gather in front of us. A medicine man had neatly set out his concoctions of herbs, which he claimed could cure anything. We watched how he captured the attention of the inquisitive group gathered around him. Different smells drifted around the immediate area - snacks being fried (both sweet and savory), cigarettes and sweat, mixed with urine from a near by open toilet becoming increasingly potent as the sun intensified. However, one of the hundred Gods meeting for the annual festival was looking down on us; we were offered a taxi share to Ambala Train Station which we accepted. The cost was minimally more expensive than the bus but quicker, safer and far more comfortable.

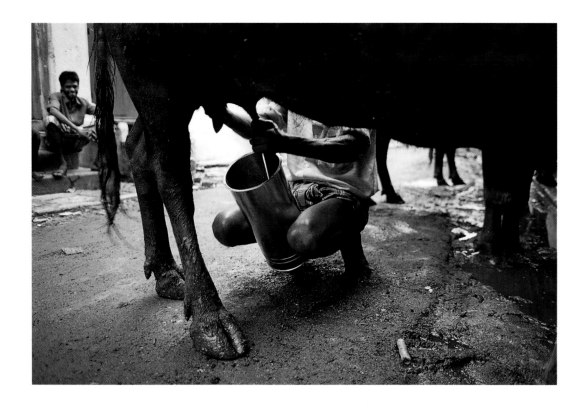

Varanasi - famous for silk, burning bodies, music and cows. Roaming the streets freely, cows get away with anything as they are the most sacred animal to Hindus. Scooping up cow turds in your open-toed sandals is one of the consequences of this. However, the locals make full use of this holy excrement by collecting, remolding and drying it in the sun, for later use as fuel.

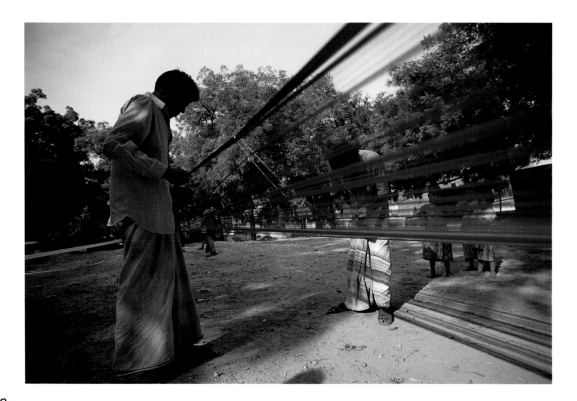

The back streets were a maze-like warren of cluttered lanes, with the cramped, high buildings providing protection from the scorching sun. Through every window came the clatter of silk-weaving machines in action and the constant chatter of the workers. Peering through the bars, we were invited in. A single dim bulb lit a small room, with weavers sitting cross-legged on the floor in cramped conditions. Smoke bellowed from other doorways. Inside, scantily clothed men were preparing the dyes, breathing in the suffocating fumes. Every space between the buildings was used to stretch out the newly dyed silk thread to dry.

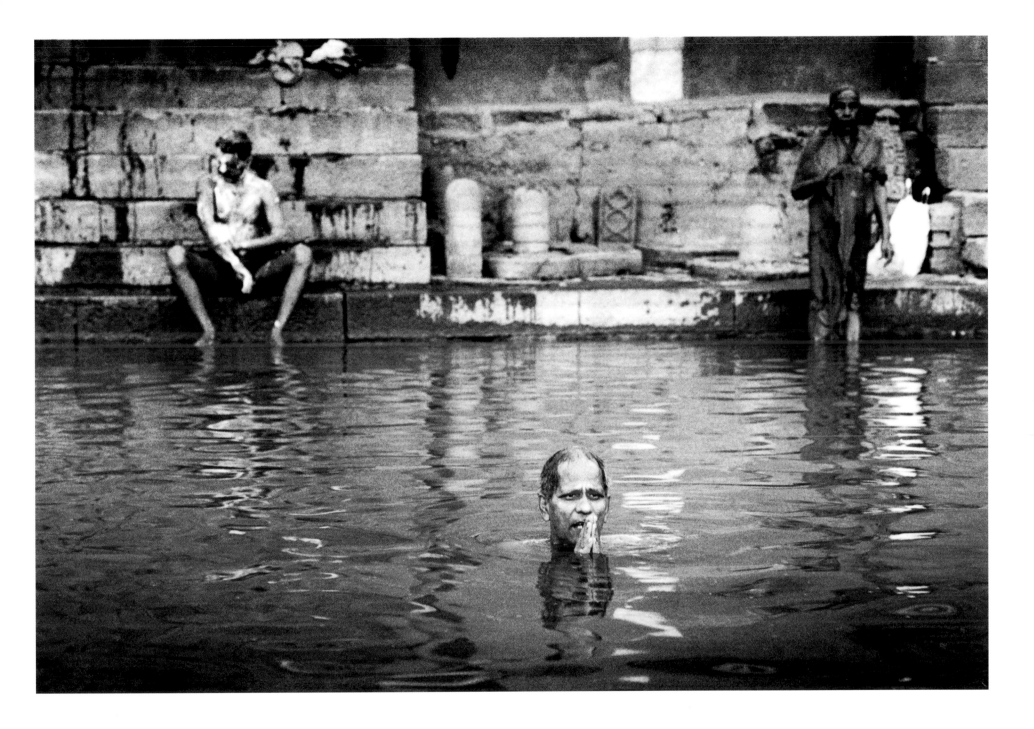

We took a dawn boat trip up river to watch the many rituals taking place along the ghats. Pilgrims from all over India come to bathe and cleanse themselves in the holy waters of the Ganges, Varanasi . To die and be burnt on the banks of the Ganges is the greatest wish of all Hindus, as it is said to be the quickest route to heaven. They do not burn anyone who has died from incurable diseases, such as typhoid and cholera, because they believe the smoke from the fires carries and spreads disease. Nor do they burn children under five, pregnant women, sadhus or those that have died from a snake bite. Instead they throw the corpses into the river. Cruising along with the tide, the smell from the burnings wafted around us, and floating corpses drifted only feet from pilgrims brushing their teeth.

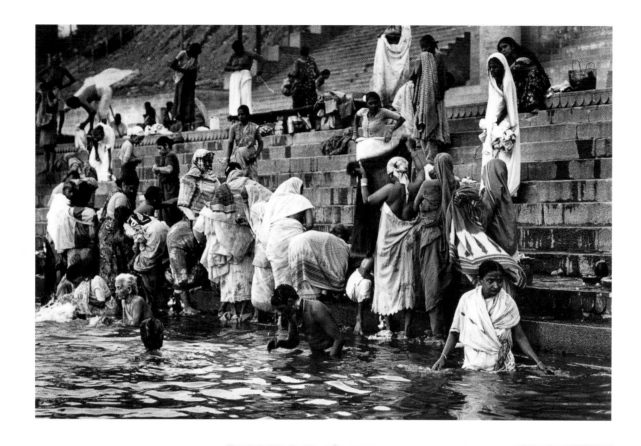

Religion and propriety mean the women wash fully clothed - an art that takes years of practice and is quite fascinating to watch.

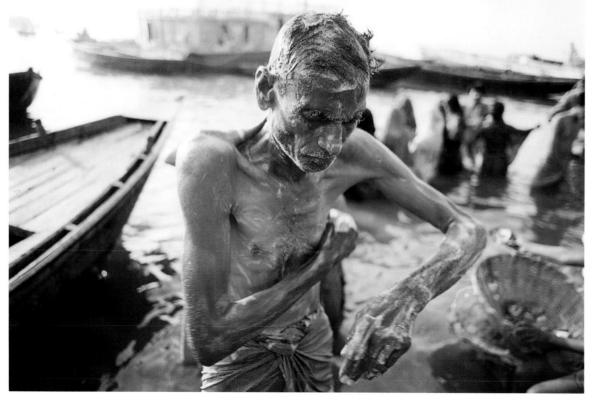

Cleanliness is Godliness.

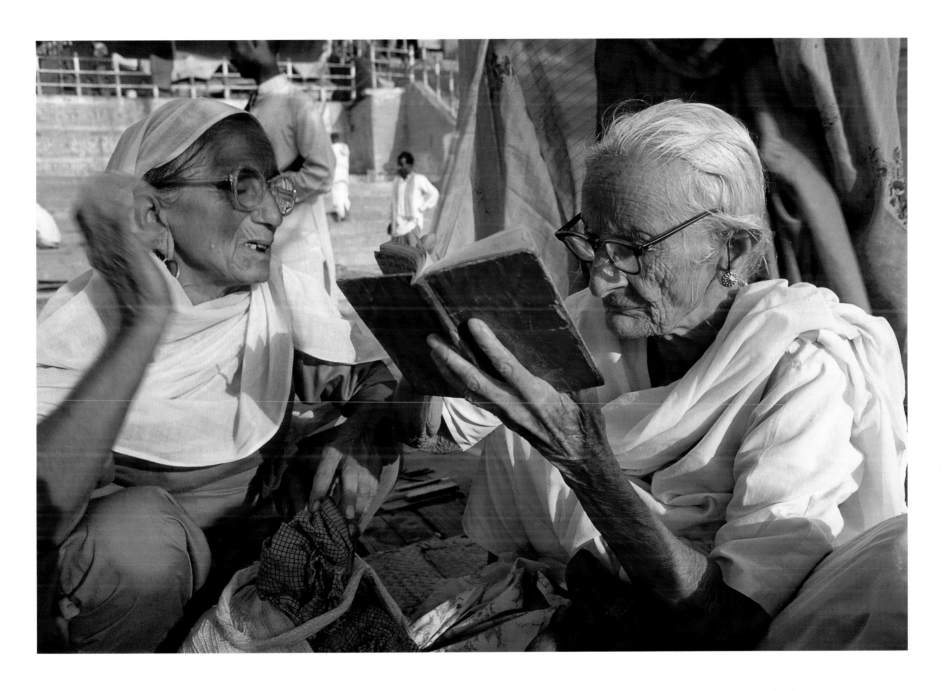

It's an incredible place to 'people watch'. Walking along the river's edge the ghats are always busy, and together with the ceremonies of prayer and worship, barbers and masseurs punt for business. Guides offer their services and traders and vendors approach every few steps -local entrepreneurs more often than not, luring you back to their 'uncle's' silk shop.

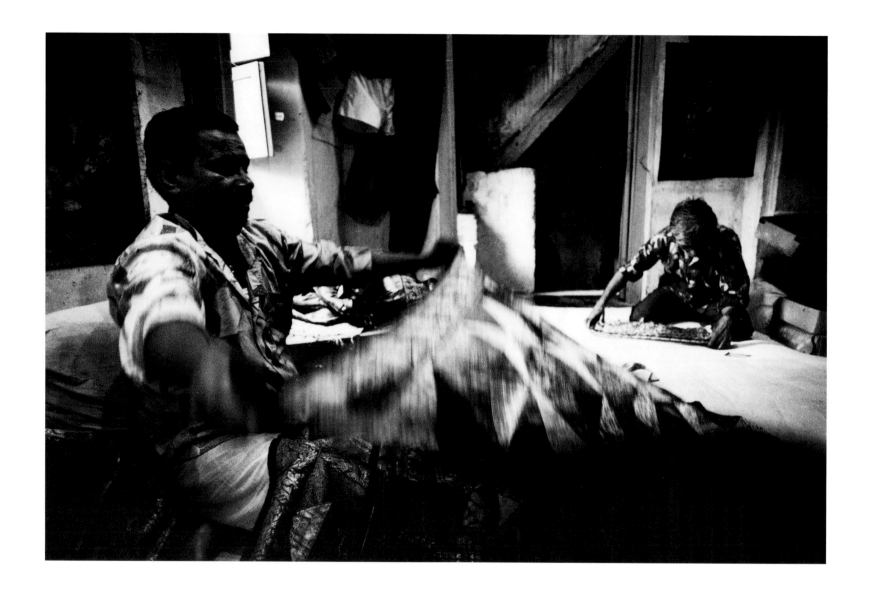

Once inside the shop it's difficult to leave empty handed. Silk embroidery of all description and colour were laid out before us, and while relaxing on the comfy mattress floor they gave us endless free cups of tea. We had hired a friendly rickshaw man for the day. He helped us barter and we put our faith in his ability to get the 'local' price. We thought we'd got a bargain, but later found out that he receives a commission. We'd been ripped off good and proper!

Having consumed a bhang lassi (a yogurt drink laced with cannabis resin) I walked aimlessly around town taking in the increasingly surreal surroundings. The confusion of streets, people, bicycles, dirt, noise and heat became too much in the Old City. Escaping, I found a quiet back alley where I sat down, relaxed and enjoyed the sensations.

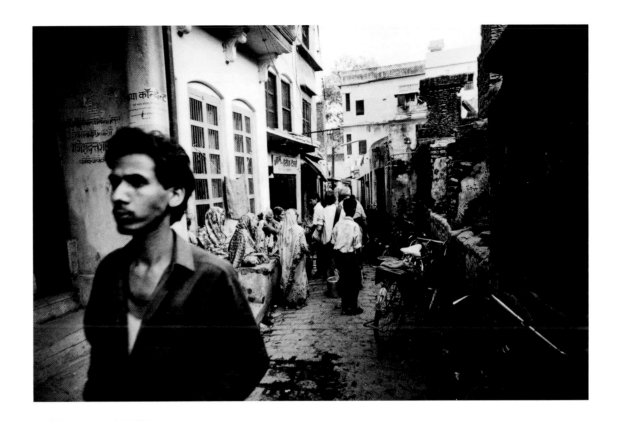

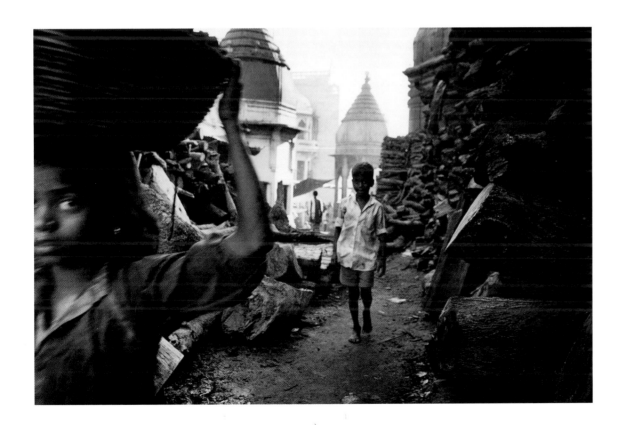

Children are sent out to work, beg or steal to enable their families to eat. They have to learn to endure hardship from an early age. The constant touting is tiresome. I found myself either ignoring them or joking with them. When approached by a boy selling carpets, and before he said his "I make you good price" jargon, I named a ridiculous price in jest. His passing comment was "see you in the next life!"

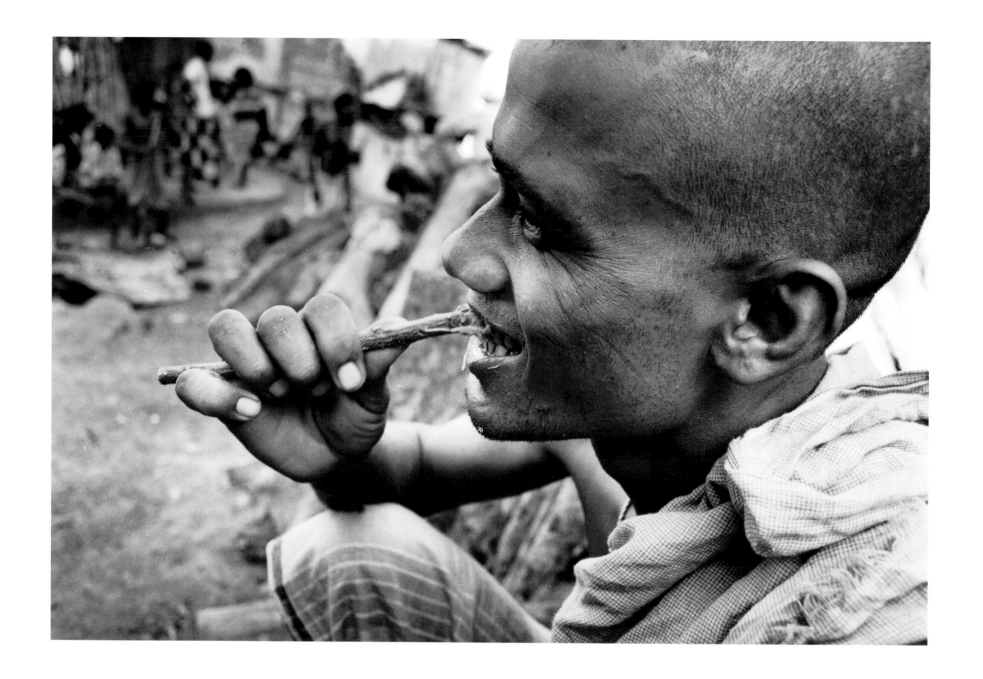

The chewing of betelnut is a popular activity - an affordable high for most. It is mouth-numbing, foul-tasting and stains your teeth red, and is a hazard along the pavements as it is spat out in every direction. Locals are so resourceful that they also clean their teeth with sticks.

Arrived in Puri, a place of pilgrimage, a beach resort and fishing village. We met up with some friends who recommended their Hotel. It was a relief not to be faced with the normal nightmare of traipsing around town, laden with heavy rucksacks, trying to find a place that is bearable and affordable. Heading straight to the restaurant to fill up on fresh fish was a welcome change from our bland recent diet of rice and Dhal.

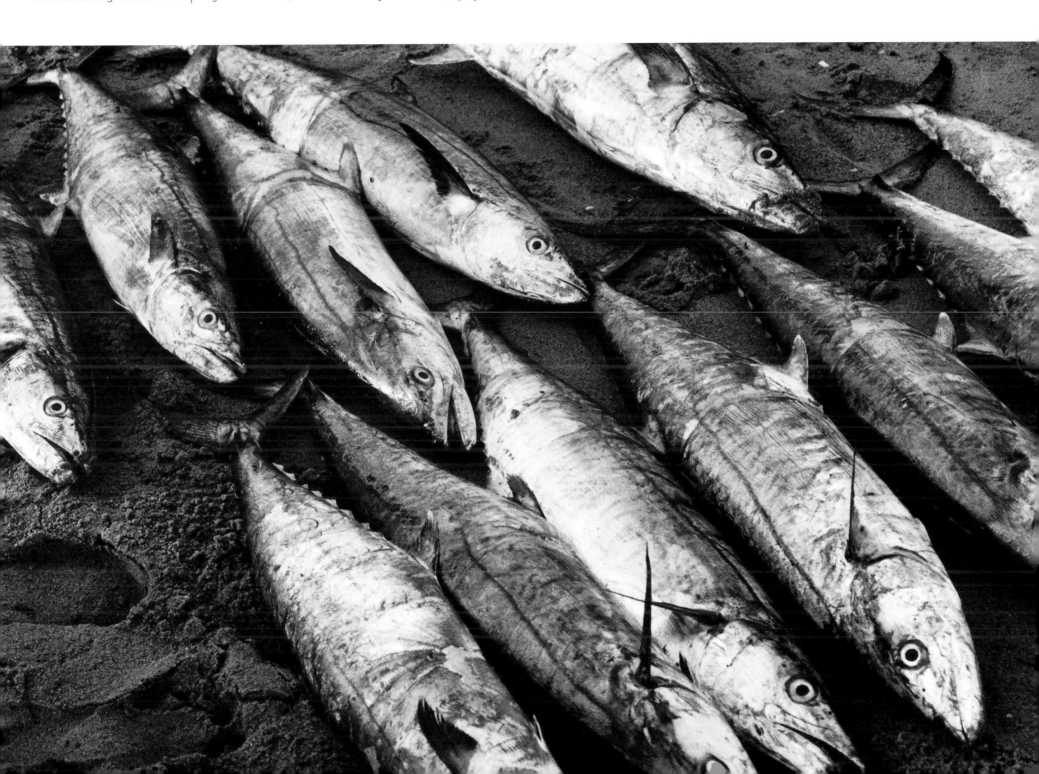

The fishing village was busy at sunrise. A usual ritual of the fisherman, after sorting their nets, was to bare their bums by the waters edge and go to the loo. This turned a pleasant stroll into a gross experience. Having to hop, skip and jump over the remains that hadn't washed away with the tide.

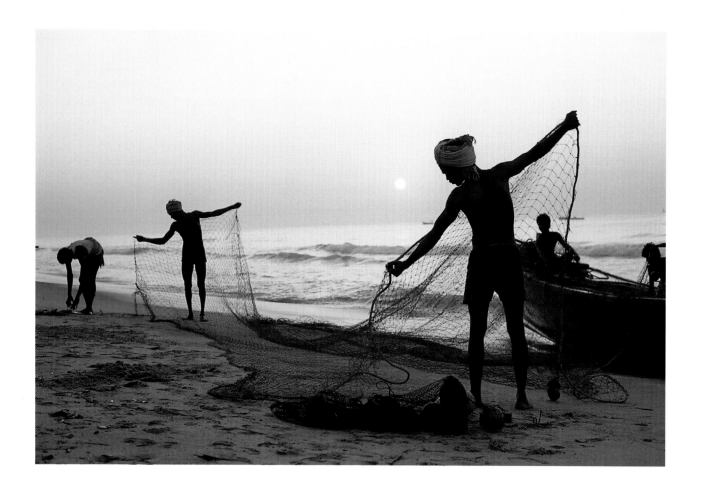

While export buyers and local restaurateurs bargained for the best catch, kids ran around nicking the odd fish to sell to tourists. Once the mornings activities had settled down, the fishermen spent the rest of the day mending their nets and preparing for their next seabound outing.

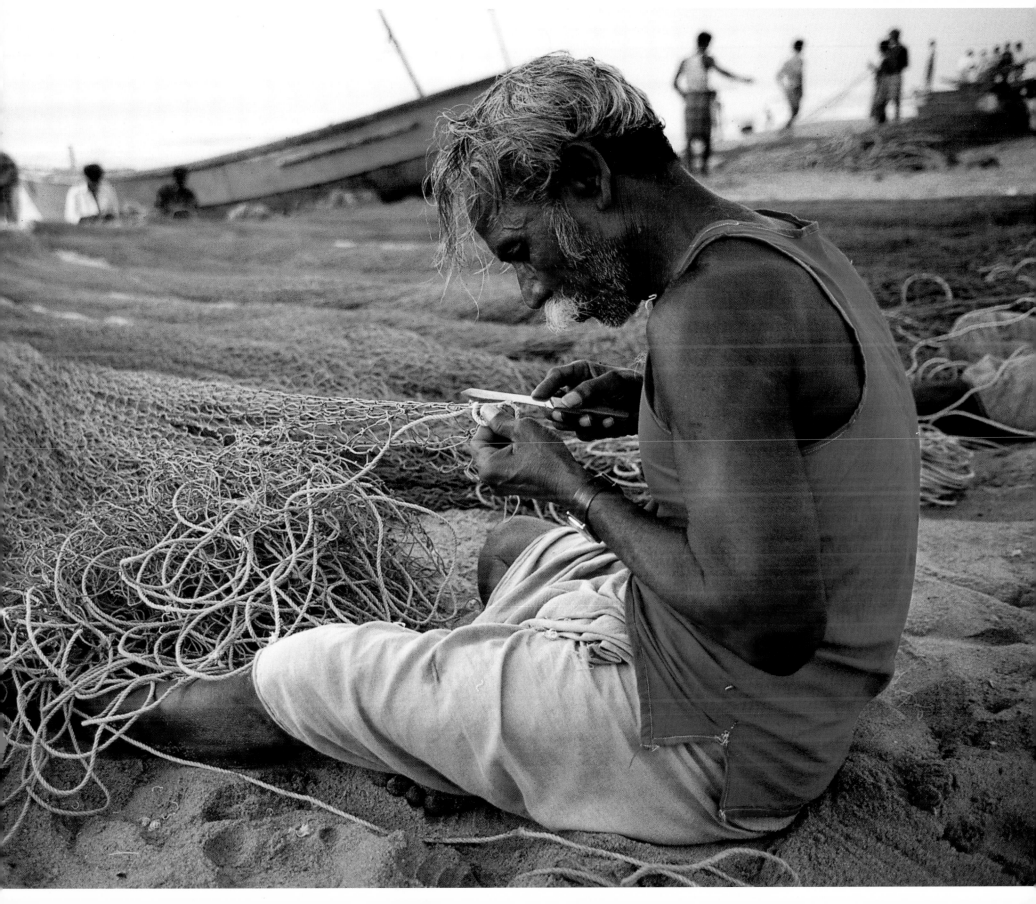

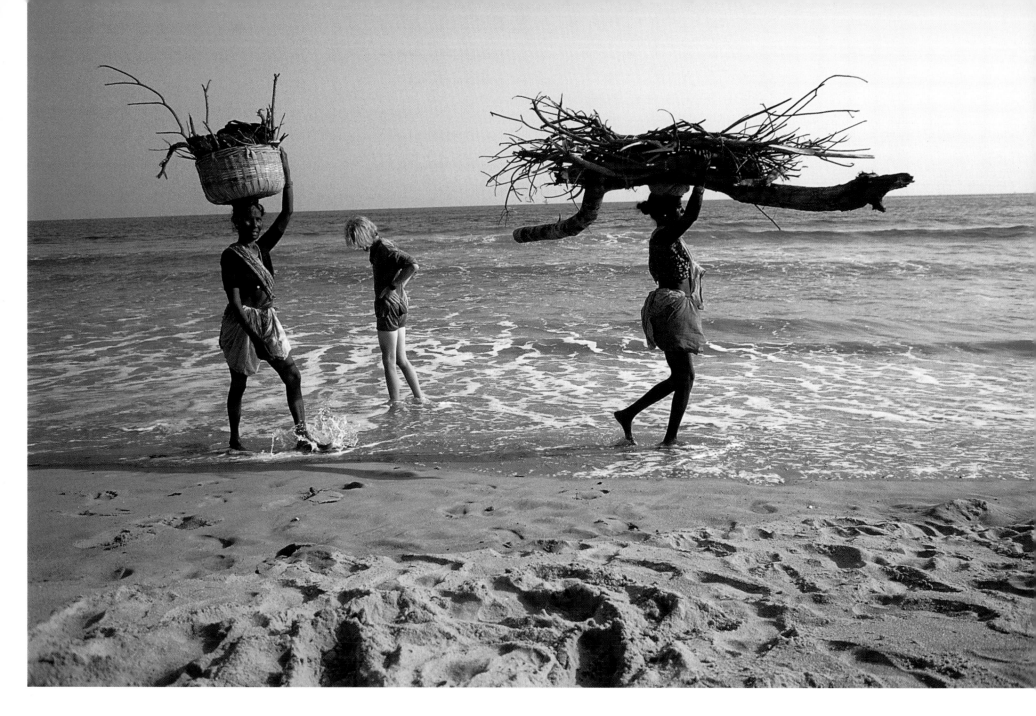

\mathcal{S}eeing women lugging firewood twice their body weight, and a young girl collecting dried human excrement for fuel, made "chilling out" on the beach a surreal experience.

It was impossible to walk through the fishing village without attracting attention. Mothers held up their babies to be photographed, everyone stopped and stared. It was at times like these I wanted to be invisible. A stream of kids came out of nowhere, holding out their hands earnestly and asking for school pens, demanding cash or gifts relentlessly. Once they had earned their daily crust, I was left alone and they went back to playing.

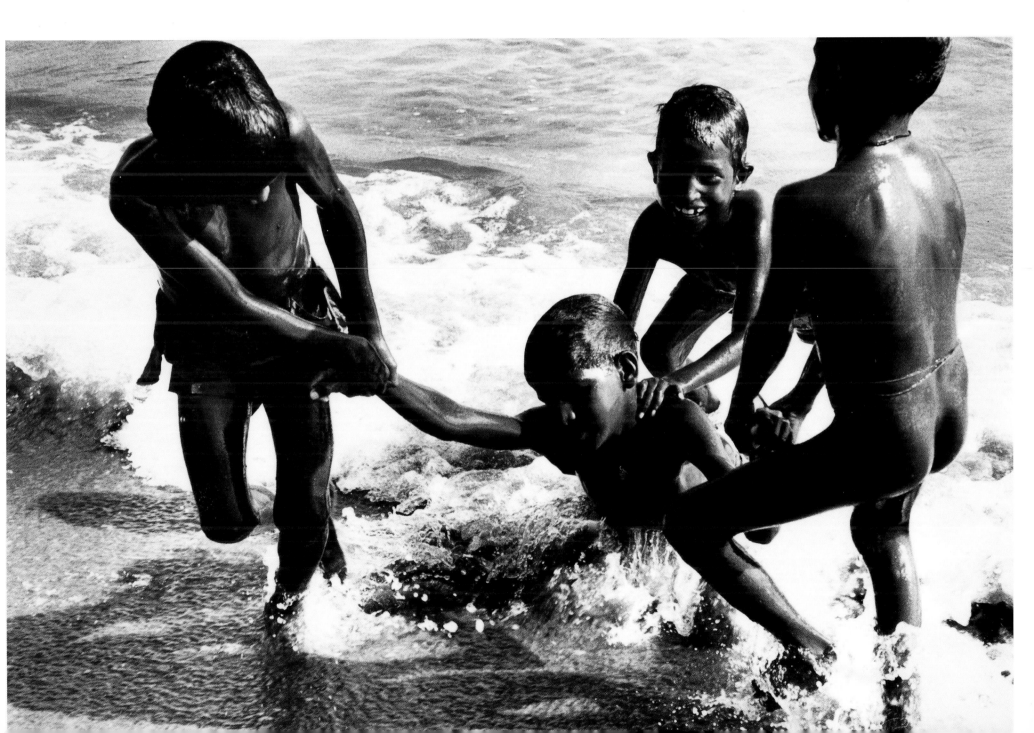

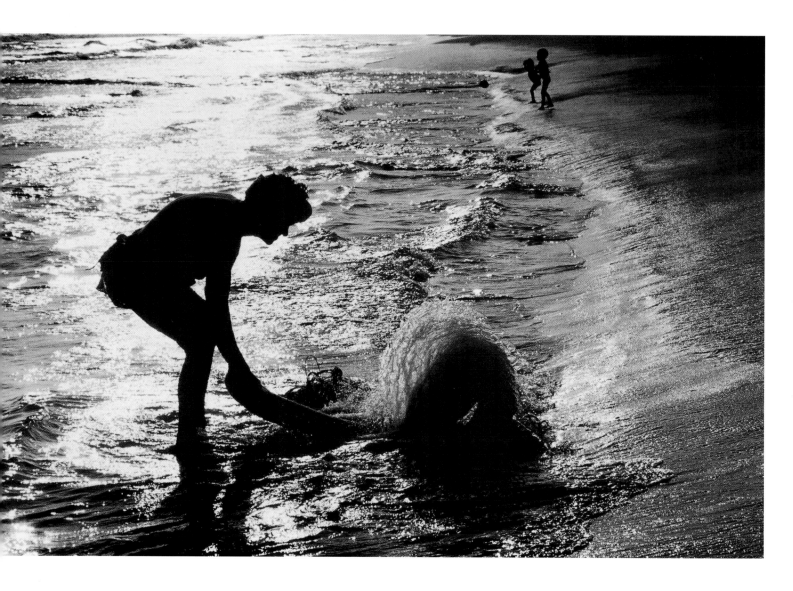

Catching sunrise for the last time in Puri, we watched the fishermen wash their nets. Smells from the fires cooking breakfast drifted our way. The fresh sea air and the mesmerizing breaking of the waves might have kept us there longer, but we had a train to catch.

As the train headed south to Madras, the sunny warm weather evaporated. The spacious empty carriages soon filled up and became cold, dark and claustrophobic. Gale force winds were brewing outside and torrential rain cut through the air like sheets of glass. I caught a headline in a fellow passengers newspaper - "Cyclone in Madras kills". Reading closer, the tales of tragedy included ten trains being derailed in the area we were passing through. The rains got heavier and at one point I thought we might become another statistic. The journey turned into a roller-coaster trip as the train left the tracks several times, bouncing us from our bunks. We passed by flooded plains and roof tops just visible above the high water. People now homeless walked across the isolated highlands, a few belongings in one hand and an umbrella in the other.

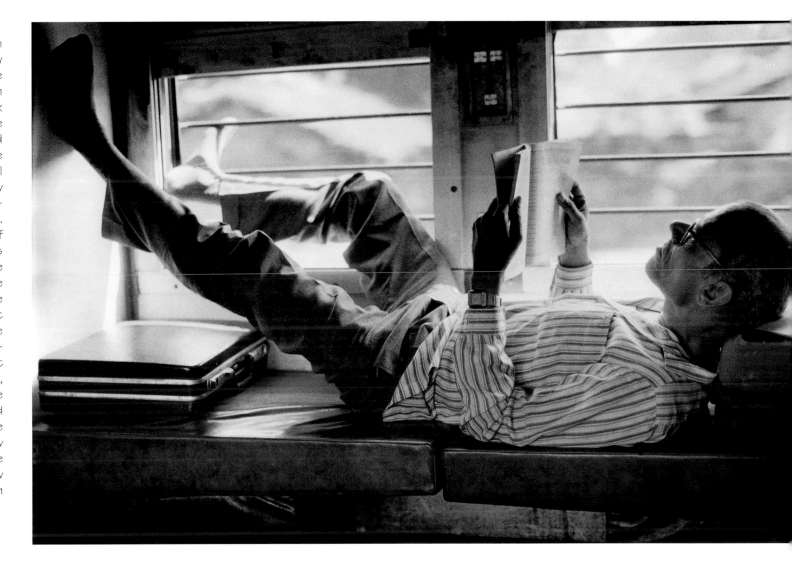

The taste of hot chilies was dampened by the wet weather. We had been stuck in various hostels in Madras and Mahabalipuram, playing Carrom (similar to pool, but played with fingers instead of cues) and other games over endless cups of tea, waiting for the rain to stop. We heard that the water level was knee deep in the surrounding area, and our assumptions that the monsoon had finished were wrong. We made a quick decision to go west, hoping for sun and a chance to dry our clothes.

After travelling for a month, adjusting our clothes to blend in with and respect local custom, we felt out of place in Bangalore. It was clean and Western, with bill boards lit up and neon signs flashing like Piccadilly Circus. Young trendy and wealthy locals hung out in cafes and bars, chatting away in English. This was Yuppie India. Wanting to escape, I went and lost myself in the traditional busy markets for the day. Looking into the confusion of people, it was difficult to see who was buying and who was selling. I was captivated by the scenes and others' joy in bartering. There's nothing better than knowing you have got a bargain!

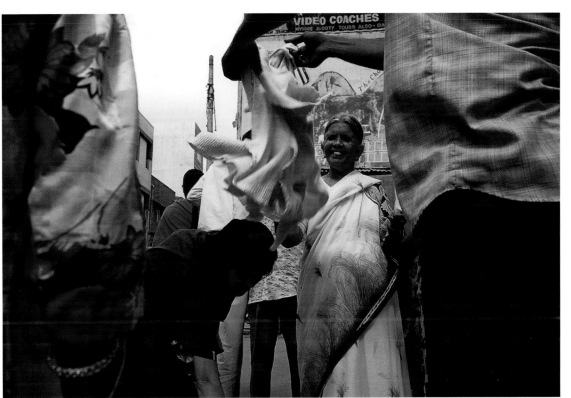

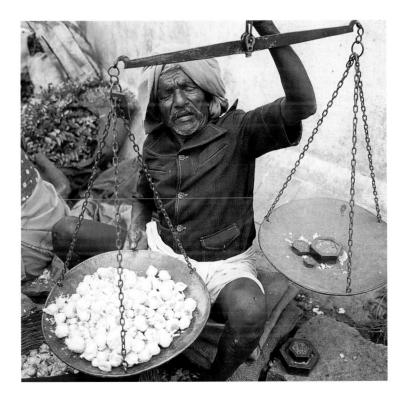

It was an explosion on the senses! Conversations surrounded me, harmonizing in pitch and tone. The herb and spice market was totally engulfed in its own cloud of delightful aromas, overpowering the smell of sweaty bodies. Swept along with the crowds, children swarmed around me, laughing and joking. They seemed harmless, but I had heard the stories of pickpockets and muggings, so was wary of them. The flower market was another wonderful sensation. Enclosed in its own fragrant world, separate from the waste, dust and fumes that pollute most of India's city streets.

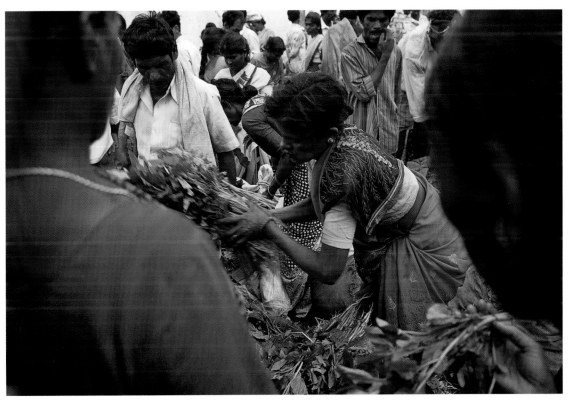

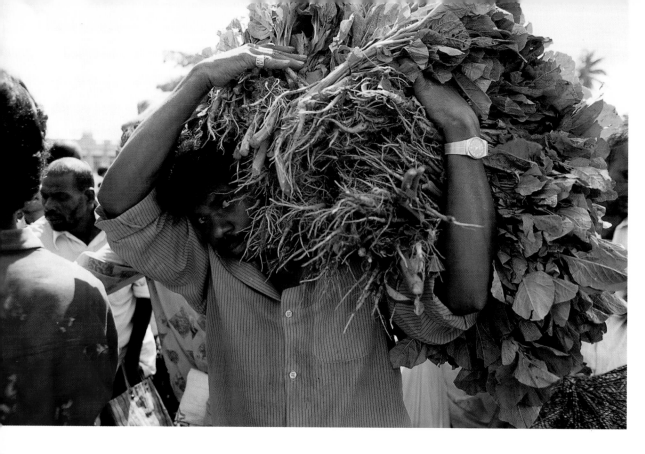
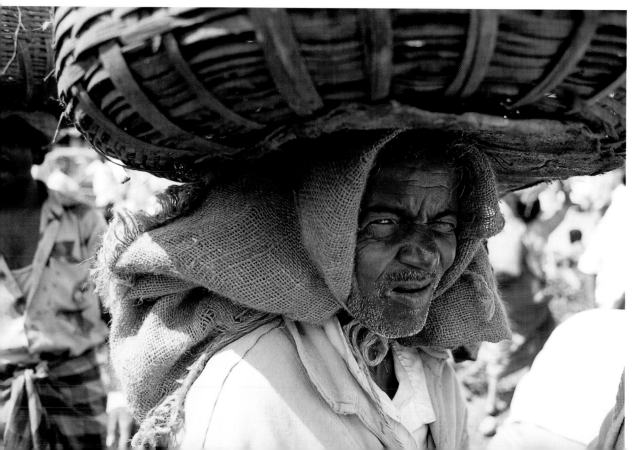

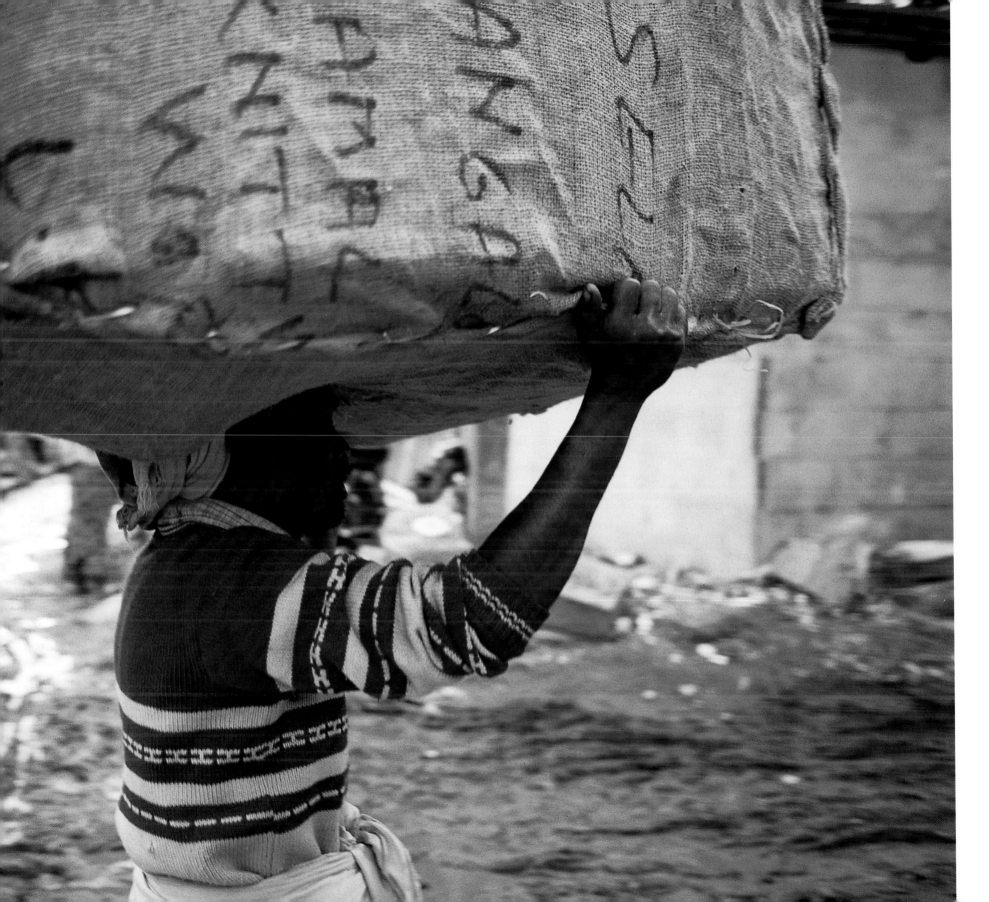

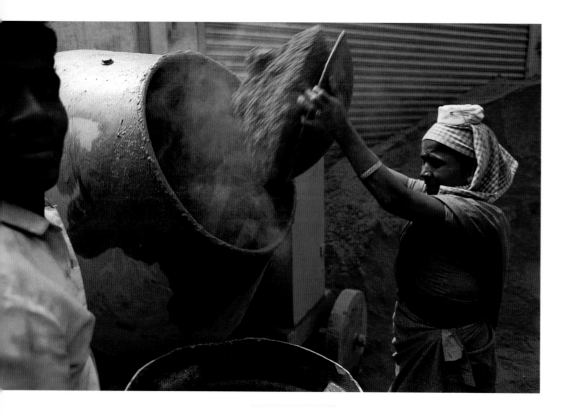

Walking around aimlessly, a building site caught my attention. The precarious wooden scaffolding held the dodgy construction together. Women were working in a conveyor belt system, carrying heavy loads of bricks, sand and stones piled high on their heads. It seemed so unfair that the men got off lightly, mixing the cement and allocating the work.

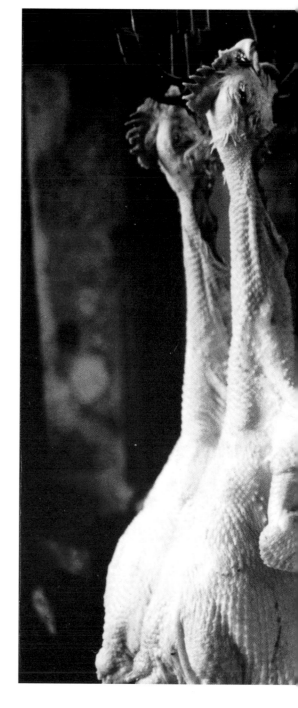

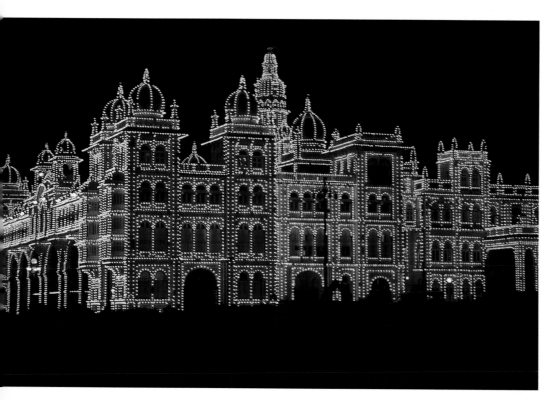

Moving onto Mysore - we arrived in time to marvel at the spectacular Maharaja's Palace while it was lit up like Disney World, which happens for only an hour a week. By total co-incidence, we bumped into my sister's best mate in a local cafe. After the initial shock and exchange of kisses and hugs, we consumed a suitable quantity of beer and discussed the unbelievable chance meeting and the feeling of fate leading our way.

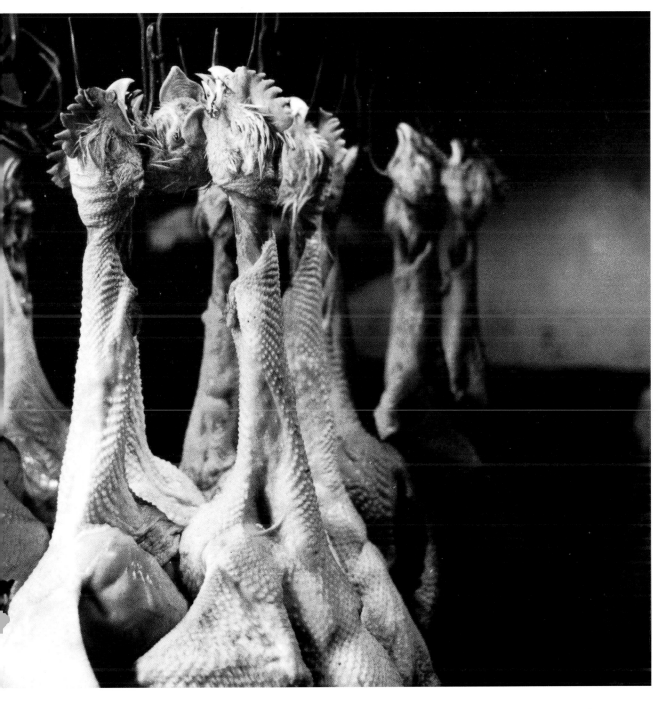

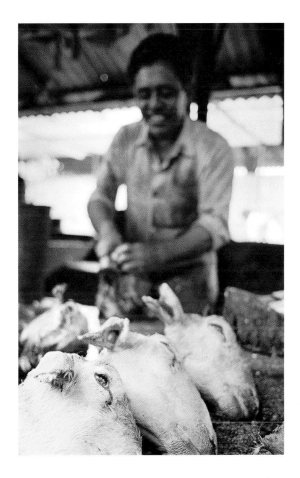

Giblets, feet and roosters red 'wobbly bits' were placed in neat individual piles for the poorer folk to make up into a tasty broth. No part of the animal was wasted.

Being vegetarian, I was surprised I didn't faint when encountering my first open meat market. Flies buzzed around and landed on exposed joints that were swaying on hooks at my every turn. It was here I learnt the true meaning of the expression 'running around like a headless chicken'. A young boy collected an armful of birds. One by one, holding them roughly by their feet, he cut their heads off, threw them into a barrel and left them to die. Squirming about furiously, blood spurted from their necks, staining their white feathers red.

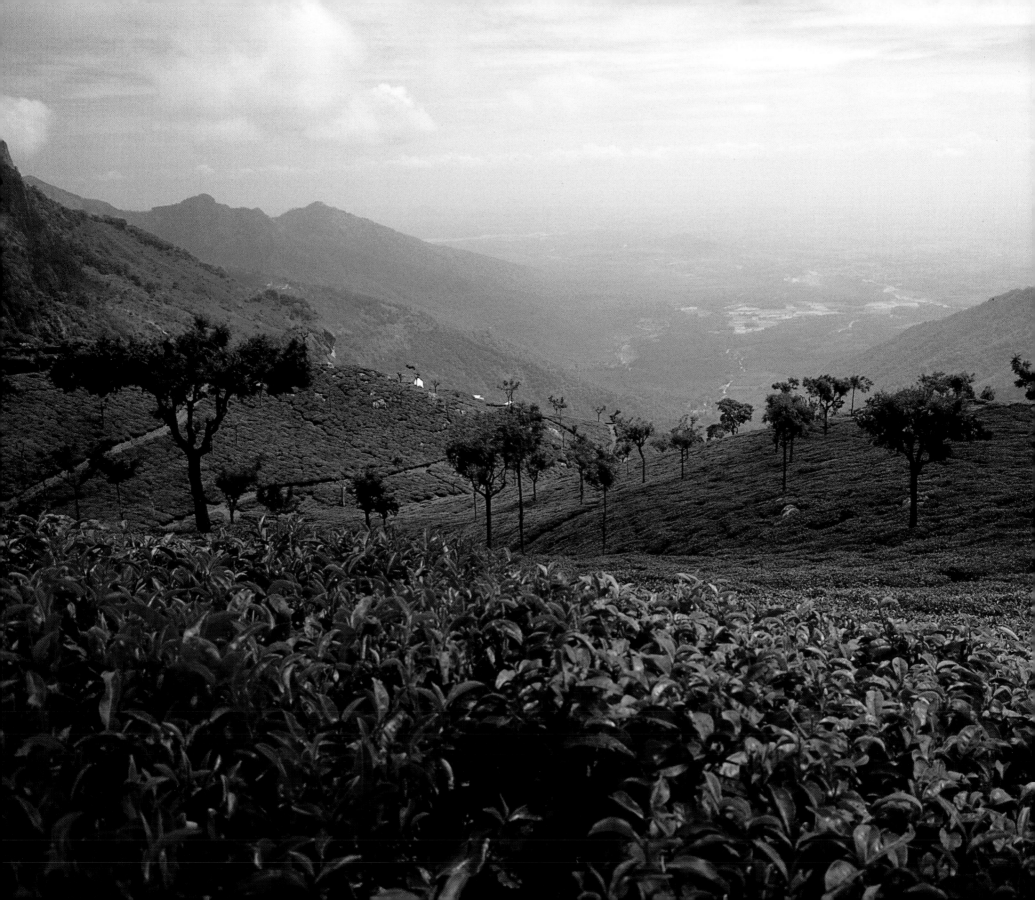

Unable to agree a fare with the rickshaw man, we walked away. Two local girls asked where we were going and offered to show us part of the way. Having chatted on route, they decided to skip work for the day and show us some tea plantations. The views were stunning. We were surrounded by a vivid green carpet which faded away into the distance. The valley below opened up and we could see the whole of Tamil Nadu.

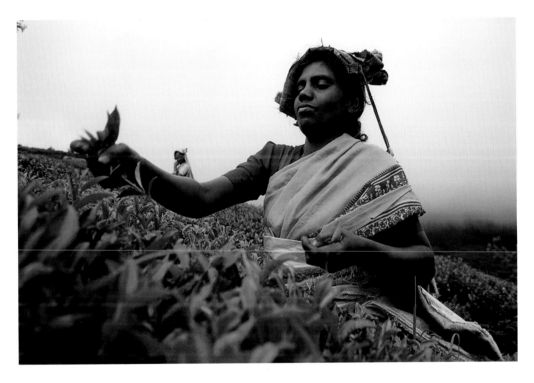

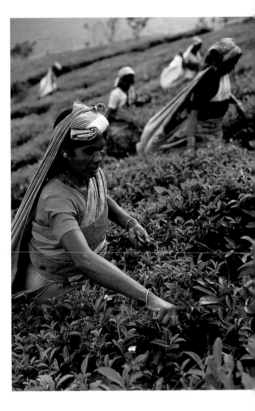

It was interesting to compare our differences in background, religion and culture. They were as fascinated by our tales as we were with theirs. They had obviously been influenced by Western culture, doubting in God and not believing in marriage. In the end all of us felt that the grass appeared greener on the other side.

Our discussions seemed strange, surrounded by people without choice. We questioned our lives and searched for more, yet they accepted their situation and just got on with it.

Project Tiger Wildlife Park was a planned destination and rendezvous with a pal from Europe. We took a jeep safari, which followed a well worn route. Our fellow passengers were Indian tourists who were unable to hold their excitement. They shouted at any sightings, all looking and pointing out of the window. No tiger with any sense would have come anywhere near us. We renamed the park 'Project Wild Tortoise', the most exotic thing we saw!

In the middle of nowhere, miles from any town, it was time to relax!

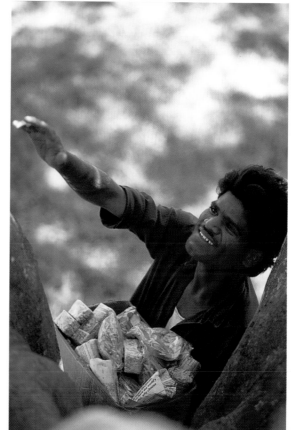

I should have known better! Wherever you are in India, someone will be around to sell you peanuts!

We took note of the warning to stay inside our hut at night. Listening to the insects and jungle sounds, we shone our torches into the darkness, and watched a hundred eyes light up as they approached our chalet in silence. On seeing the tragic state of this monkey next morning, barely alive, we were glad our curiosity hadn't tempted us to venture out!

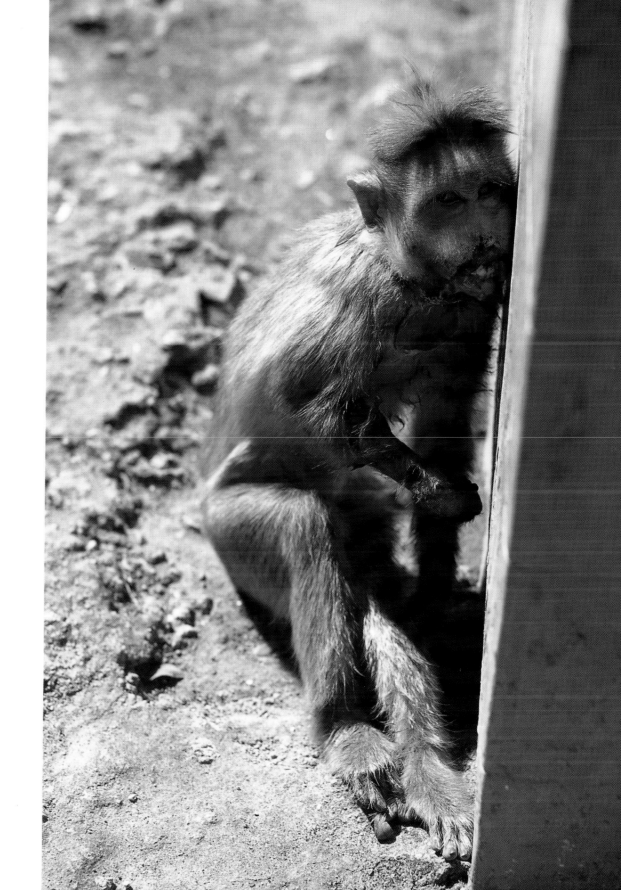

Drawn by the views, I hardly noticed my numb bum after another eleven-hour bus journey. Discomfort was becoming the norm. We stopped at Jog Falls contrary to recommendations of fellow travellers. Although less dramatic than when in monsoon, the falls were impressive and peaceful. After an energy packed breakfast of jam chapattis, we descended the waterfalls' twelve hundred steps. On reaching the bottom our legs shook uncontrollably, but it was worth it.

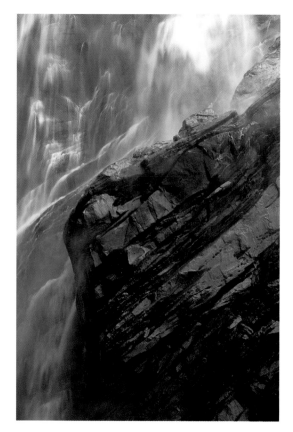

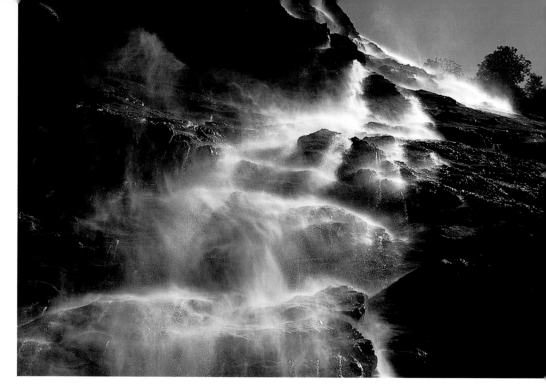

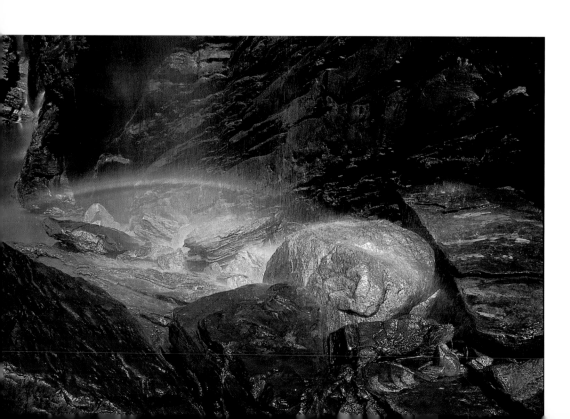

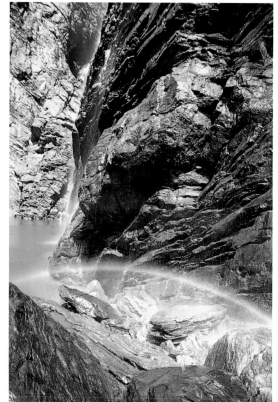

The rock pools were inviting but our thirst unquenched. Even though surrounded by litres of crystal clear fresh water we didn't want to risk drinking it. But like a gift from the Gods, the drinks man arrived laden with Coke and fizzy pop, the price doubled for his effort of descending twelve hundred steps. The gushing waters sent spray over the rocks. When the sun came around and hit the water, a three hundred and sixty degree rainbow surrounded us. We stayed for hours, even though we knew we'd miss our bus. Oh well, we'd have to stay another day!

Another twelve-hour journey, but soon all the discomforts were washed away as we smelt the fresh clean sea air. Fires were raging, locals were welcoming and their homes spacious and set apart from each other. Surrounded by palm trees silhouetted against the vivid tangerine haze, we thought we'd arrived in paradise.

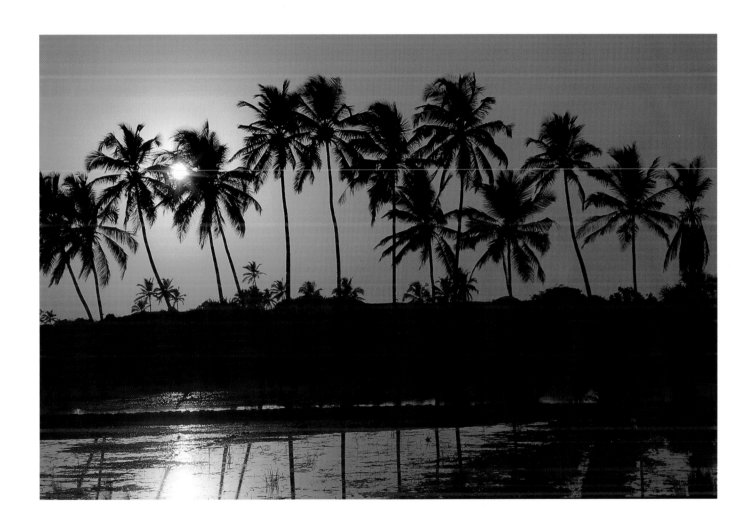

A way from the hustle and bustle of the cities and towns, Goa is peaceful and quite removed from the rest of India proper. Owing to the travel fraternity of hippies and the recent tourist boom, there is a constant stream of sellers ever persistent in offering their wares and services. They scour the beach for new arrivals (lack of tan is the give-away) and catch them unawares. We were caught out by an ear cleaner who told me I had a stone inside my ear and could only extract it if I paid him one hundred rupees. Realising it was a con I managed to bargain him down to forty. Depending on how paranoid or wealthy they thought you were, they carried on repeating the process. A guy I met got done for six stones, which cost him ten pounds stirling.

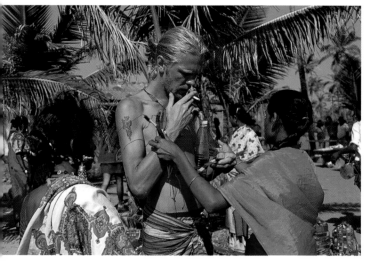

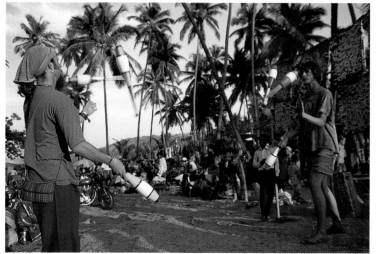

The flea market an entertaini alternative to s bathing. You ca shop until you dr (or run out money), picking trinkets from all ov India and Asia, hor made jewellery a other paraphernal Watch the freaks, join in the jugglir workshops and oth performin entertainers learnir old tricks ar swapping new one It's a meeting plac a watching arer and a learnir experience.

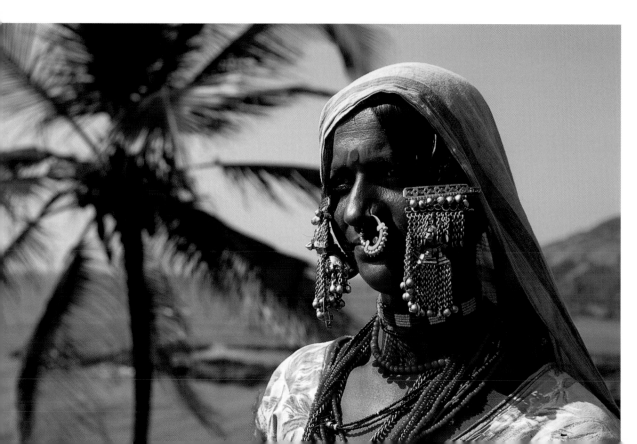

L ocal traditions are still alive, but Western influence is strong. You can almost forget you are in India with the masses that come here from all over the world, whether it is for the parties, beach or culture. Goa is also a popular resort for natives. One shocking story brought to light the degrading impact of Western culture: Buses and private coach loads of male Indian tourists descend on the area at weekends. They flock to the beach to gawp at the freely exposed white breasts. If at the end of the day they have not seen a pair, twenty five percent of their fare is refunded. More often than not the tour ends at one of the parties, where they try to touch what they saw earlier.

All journeys were mad. Partly because of the roads, but mainly because of the driving. There is no test to pass and there is a blatant disregard for any sort of highway code. Cars, buses, lorries, pedestrians and cycles cross each others paths 'willy nilly'. The loudest horn has right of way and every driver assumes theirs is! By using it, it gives fair warning to everyone where you are and diminishes responsibility for the frequent accidents that occur. The roads aren't wide enough for two vehicles let alone five. This doesn't stop drivers passing with peculiar regularity. The vehicles are ancient and lack acceleration which makes veering between obstacles a heart stopping skill. However, it is amazing how you adapt, and within days of arriving everyone is there on their Vespas and Enfields, kicking arse with the horn and copying the local driving technique.

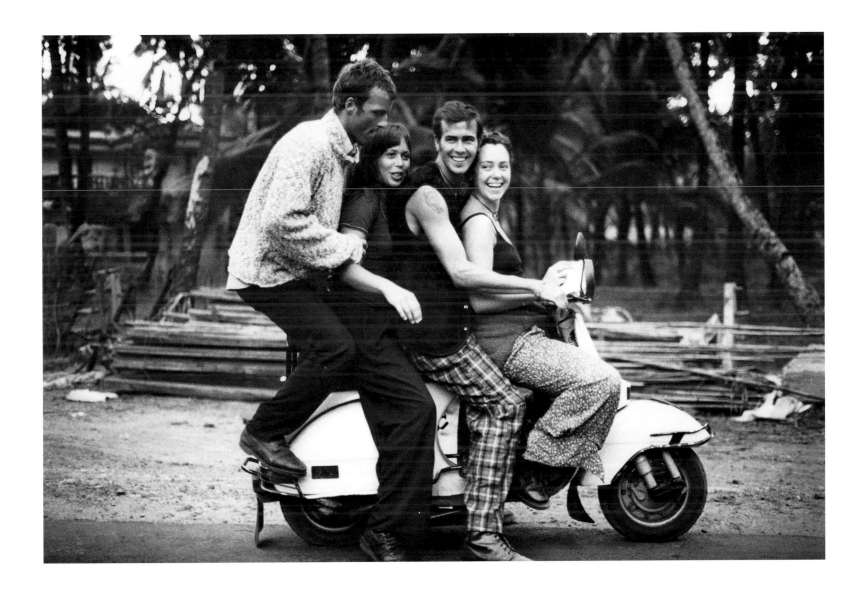

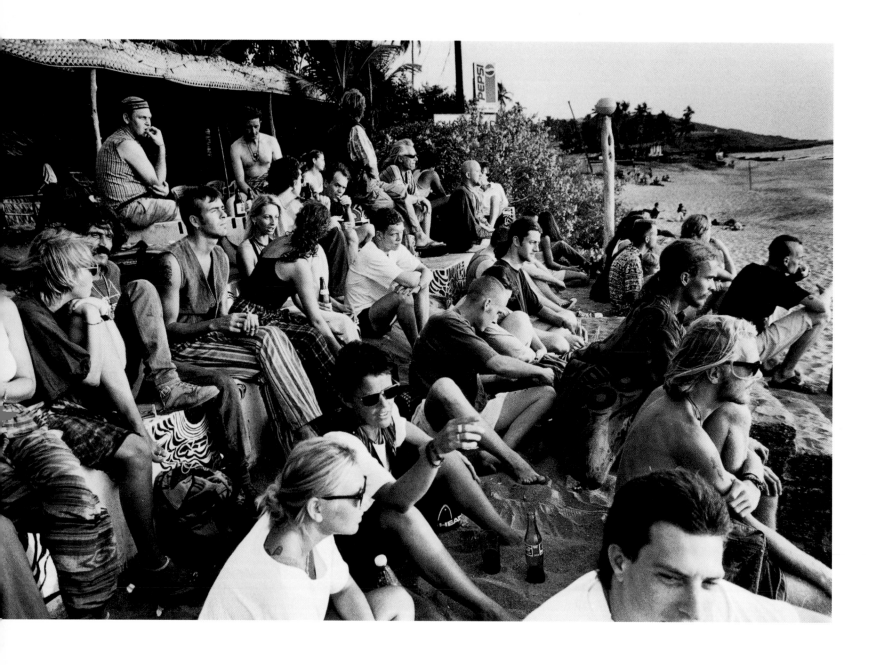

Watching the sun set was a daily ritual. Even the straightest of people chatted to strangers, describing its detail and comparing it to previous evenings. For many, the day started here. Meeting at a chosen cafe was just the start of a long night ahead.

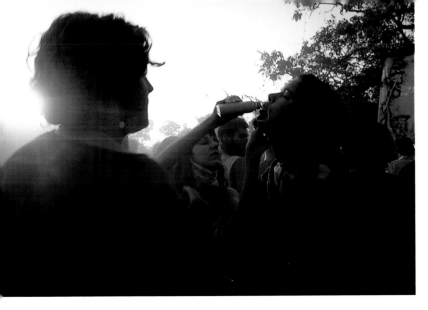

The parties raged throughout the night. At one venue, just before sunrise, a girl I had never met before asked me to follow her. Holding my hand she led me away from the party and into the field behind. "Just look at that" she gasped in awe pointing up. There was a huge diamond in the sky! I was looking at Venus, the morning star. It was totally mind blowing! We stood together in silence, while the faint beating of techno echoed behind us.

After sunset, word spread of a party venue. Everyone took to the road in convoy on their Vespas and Enfields. The tribe had come together and the party kicked off.

Behind the party a gathering of chai ladies and traders sat unaffected by the rhythmic beating. As the day wore on, more and more people slowed down and chilled out.

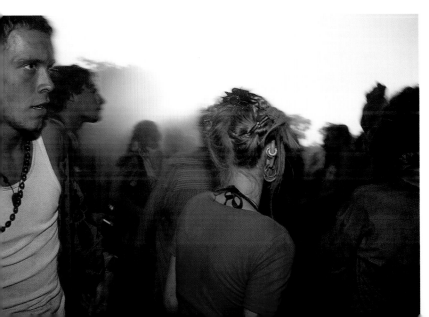

As the sun started to rise above the stomping dance party, a cloud of dust covered the mass of bodies. My mind had created a picture of the environment and the company I was in. Faces became clearer as luminous face paints wore off. The image I had created was different, it all got confusing. I walked from the dirt haze to explore other areas.

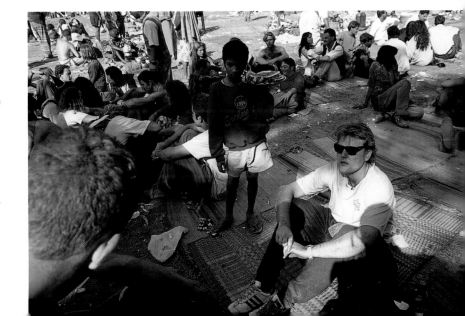

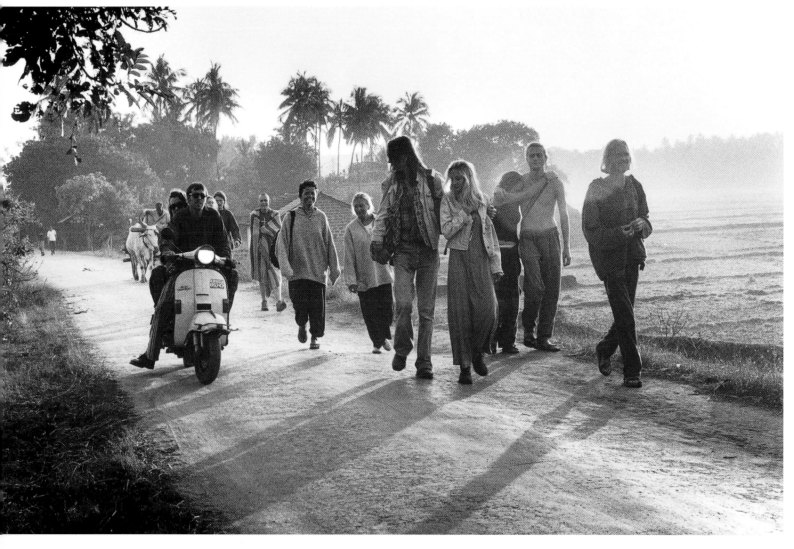

Another morning, another party finished, it was time to head for the beach for some long overdue sleep.

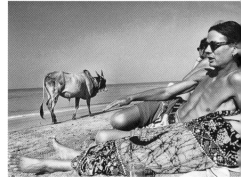

My mum's greatest fear was that I'd go home with my nose pierced.

People say that if you travel with a partner and survive, it's solid proof of the strength of the relationship. Many I met had left their home shores as a couple, but the freedom and lifestyle had split them up. It's never easy, but when it works there's nothing better than being able to share the experiences with someone.

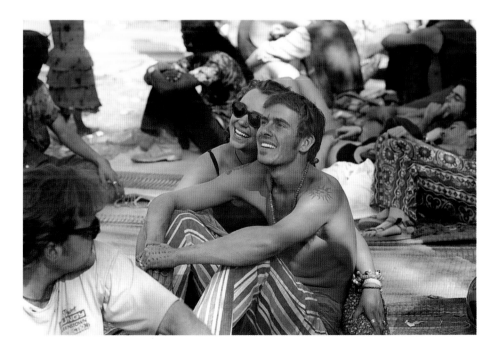

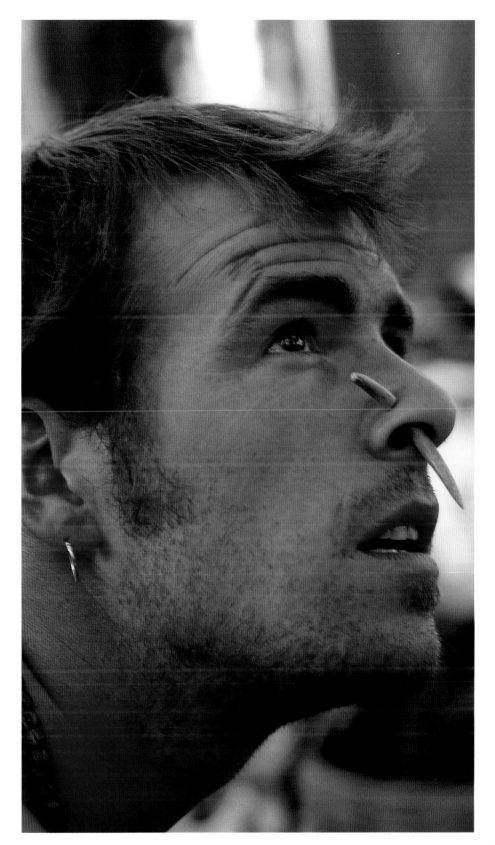

49

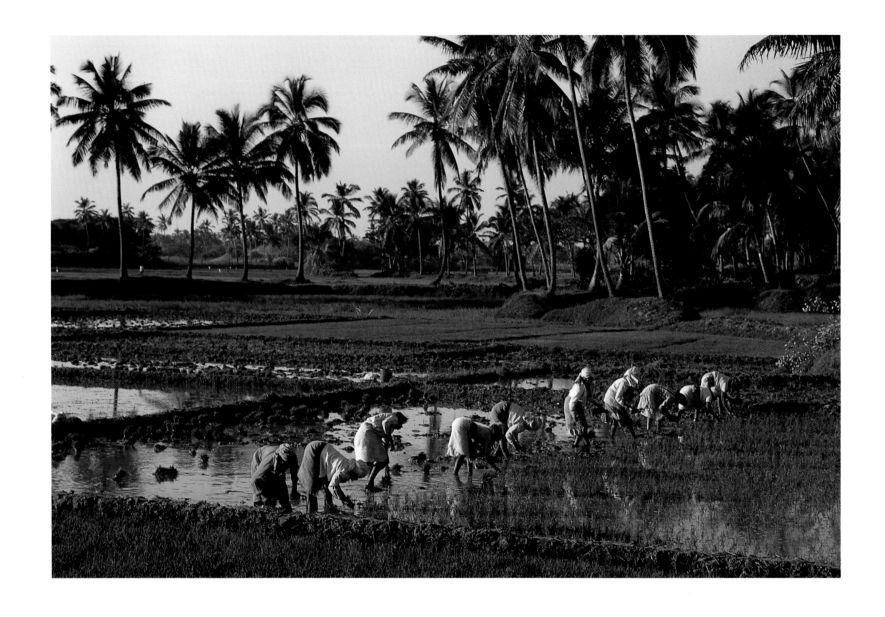

It's only when you explore and get away from the tourist areas that you get to see the local life carrying on behind the scenes. There is a lot more to Goa than just parties.

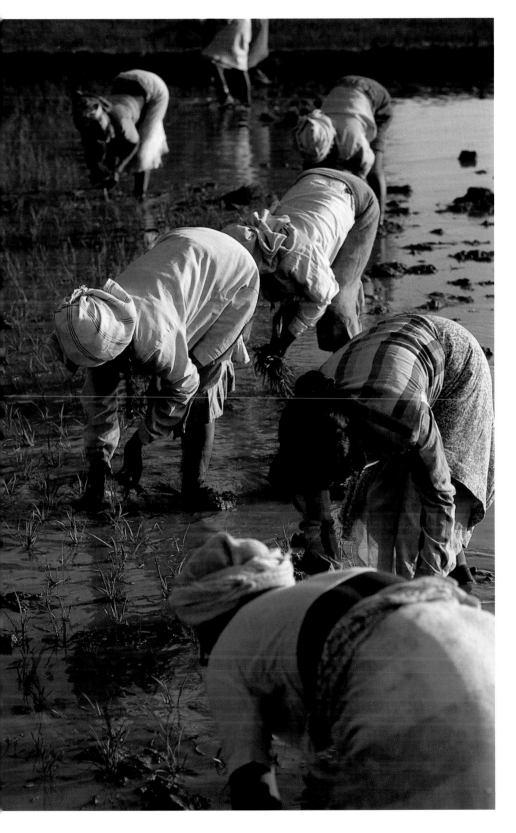

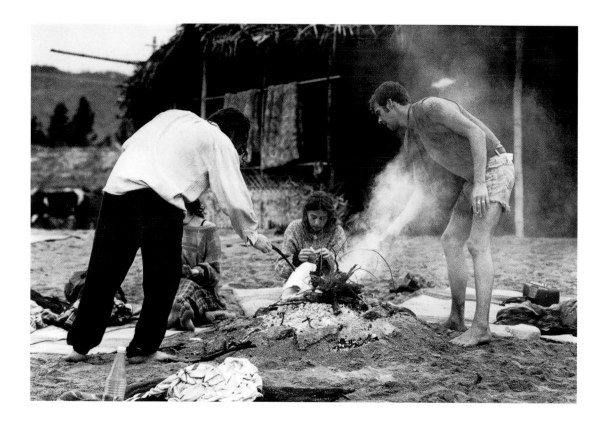

A posse of people took off on a mission to Om beach - peaceful, secluded and unreachable by road. We slept rough on the beach under a chai stand for two nights, and got caught in a freak monsoon. One guy thought that he was hallucinating when the dripping started. Another woke up dreaming that someone was spitting at him. Sleepy and swearing, everyone panicked, grabbing their gear and huddling together as the rains poured through the loosely woven leaf roof. The sight of a small Tibetan guy running around throwing his arms up in despair, chanting "same, same, inside outside!" lightened our spirits. Somehow a fire was started, the rain subsided, the sun came up and the previous evening's nightmare became just another classic adventure.

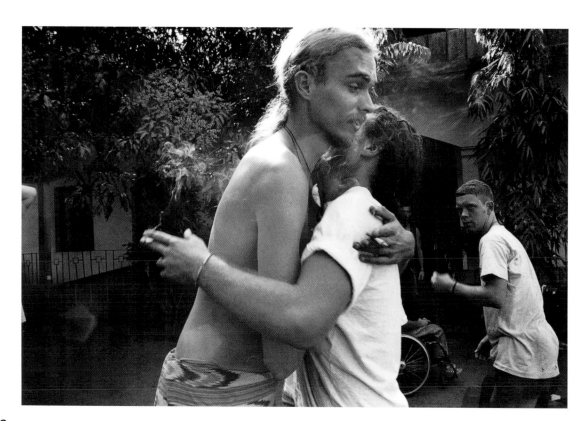

I was always daunted when I arrived in a new place, especially when it was so full of Westerners. Having spent so much time being out-numbered by natives, seeing so many foreigners looking settled and knowing each other made me feel distanced. How would I fit in? In reality it proved easy because everyone feels the same when they arrive. The settled Westerners were only too eager to meet new people, to share stories, backgrounds and adventures, which led to open trusting friendships. Despite the quick manner in which people met, it was always difficult to say goodbye.

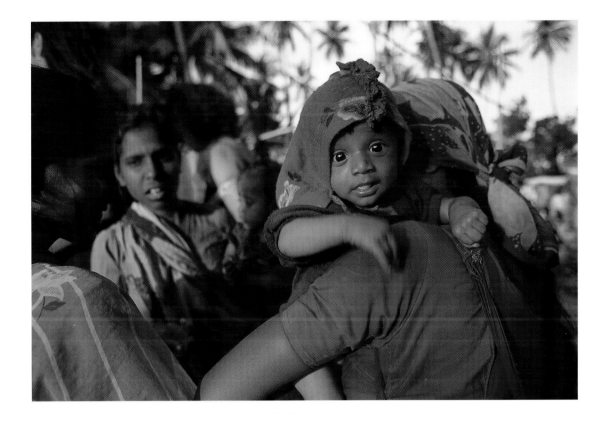

We got an impression of their lives, but what sort of impression did they get of ours?

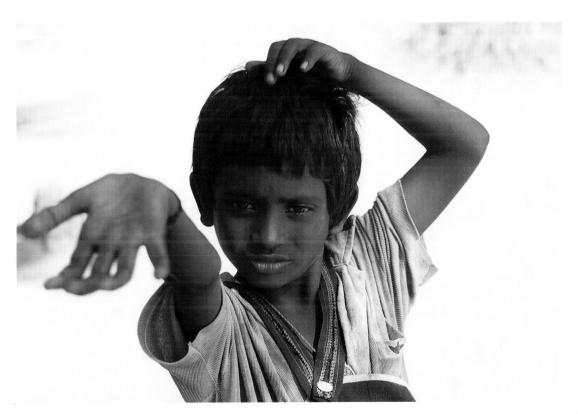

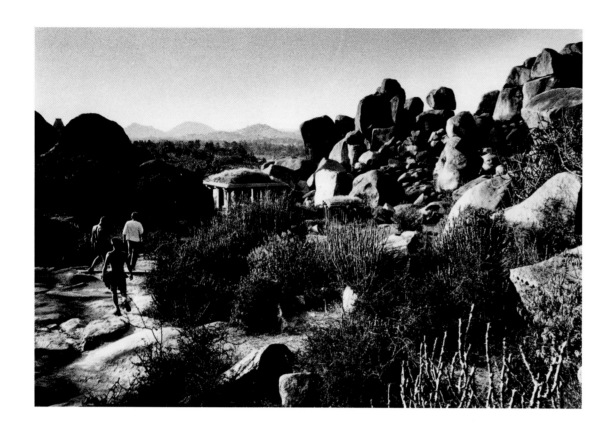

After a sleepless night on a train and bruised bones from a bumpy bus journey, we arrived in Hampi. It felt as if we'd landed in Bedrock out of the Flintstones. The lush vegetation disappeared and was replaced by a dry, surreal landscape strewn with enormous boulders. As we walked over the land and discovered the masses of caves, temples and ruins of a long forgotten city, we felt its hidden magic and overwhelming spiritual aura.

This sleepy village full of religion and history woke up to hoards of party-goers descending on it for the full moon. The population of eight hundred doubled over night, quite a shock from the usual trickle of tourists that pass through.

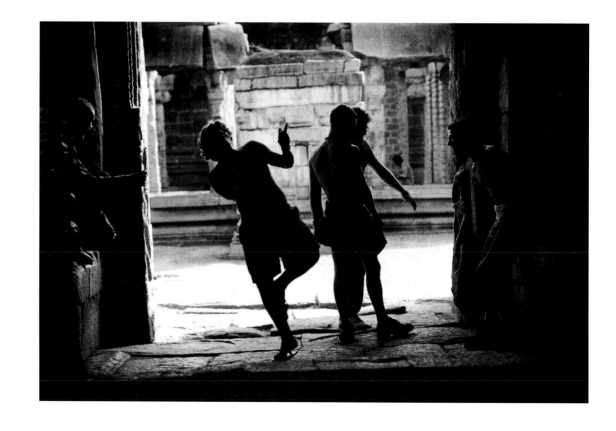

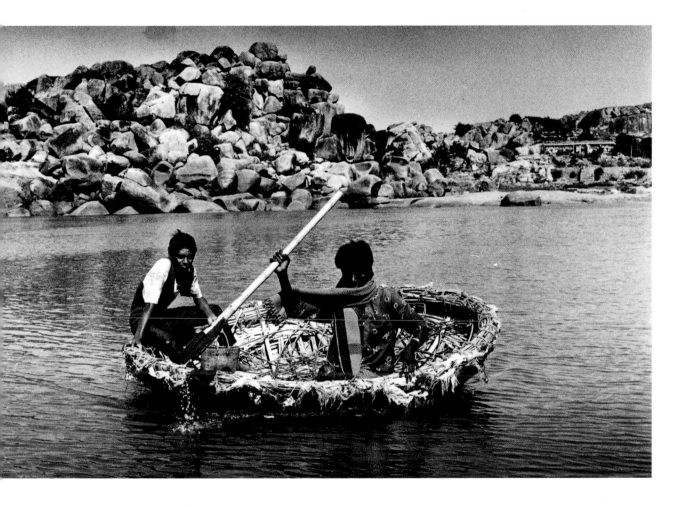

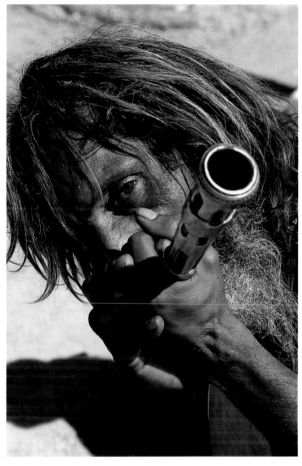

*O*ur next quest was to seek out the Golden Chillum (a smoking pipe made of gold). We risked our lives in a boat, which resembled an upside down giant coconut shell, which we had to bail water out of as we crossed the river. Then walked miles, through banana plantations, stopping off for refreshment at chai shops before continuing to follow vague directions. Getting lost several times, we arrived at the temple exhausted. We were gutted when the keeper refused to let us see the mystic pipe, so we invented a story which included trekking for days just to see it, and he eventually agreed to show us his sacred treasure.

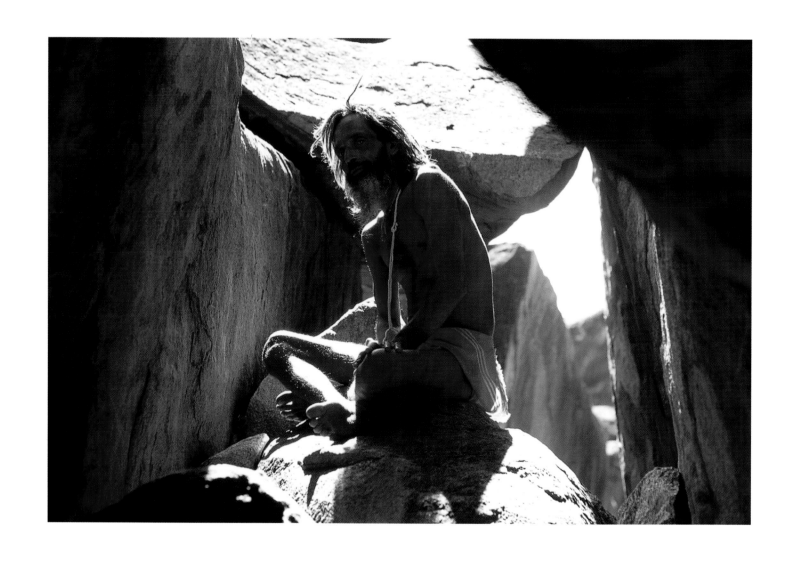

There is fulfillment in just being , rather than doing.

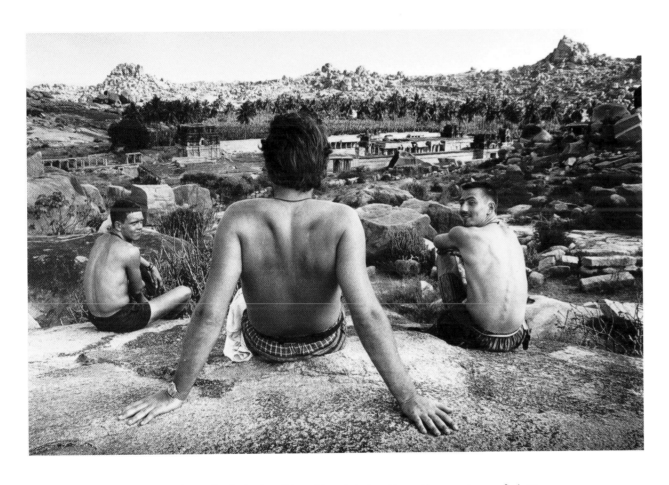

"This is it! I really think that if I could explain to others the experience of what I'm feeling now, they would give up whatever they were doing and search for this."

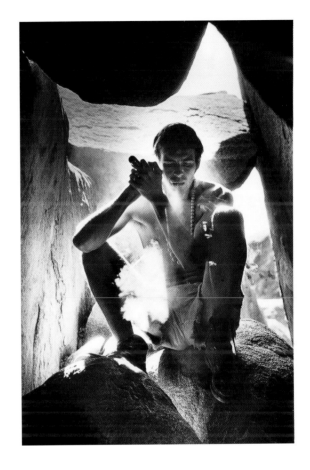

"Life's a bitch, Boom Shiva!"

Conflicting travel plans meant I had to say goodbye to the friends I had been with. This was hard. Alone again, I boarded the sleeper train to Ernakulam, I was scared yet excited. Thankfully my journey was shared, the first part with an English couple and the remainder with an old Indian woman who shared her lunch with me and helped bargain for a rickshaw to my hotel at the other end.

Seeking solitude away from the masses of party goers, I found myself sitting next to a sadhu in an isolated temple ruin. No conversation took place, but a deeper understanding did and an acceptance of each other. I watched as he prepared himself a chillum, carefully crumbling the hash into the tobacco and packing it into his pipe. Curling his hand around its base, he took it to his mouth, then lighting a match, he drew long deep breaths. He passed the pipe towards me whilst exhaling the bellows of smoke. I declined. The landscape was surreal enough. We sat together enjoying the moment.

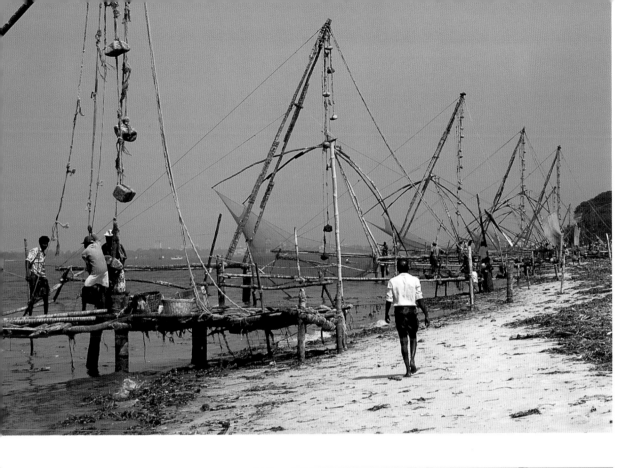

Fresh air was the order of the day after a night of non stop interruptions. A guy in the room opposite mine kept on pestering me to have a drink with him. Turning him down politely, he persistently knocked on my door and turned the lights on and off from the power switch outside. It was only when I caught him red handed, and complained to the manager, that he left me alone. Walking alongside the Chinese fishing nets in Cochin, I found the peace and fresh air I was looking for.

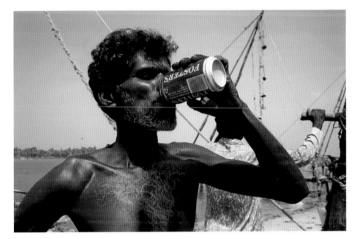

Time for refreshment. It refreshes the parts that rice and Dhal can't reach!

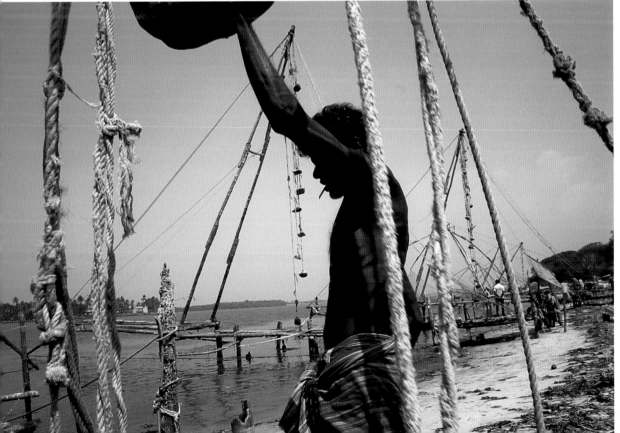

The smell of fried fish and garlic drifted along with the usual coastal smells. I couldn't resist buying some freshly caught tiger prawns and had them cooked in a cafe nearby. Watching the world go by, I tucked into my prepared to order brunch which had been caught only feet from me.

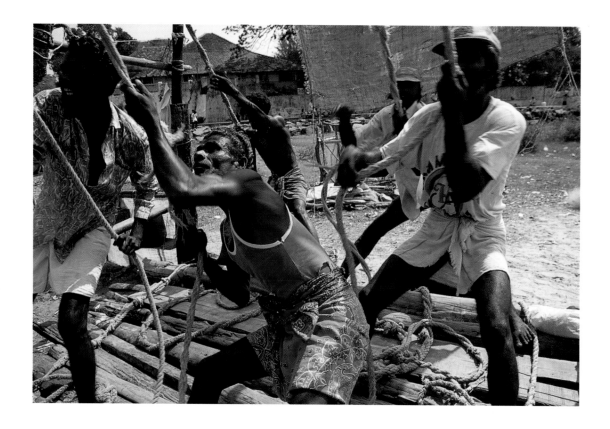

I got talking to the fishermen who invited me to help pull in their catch. After a couple of times I was pooped and let them get on with their work.

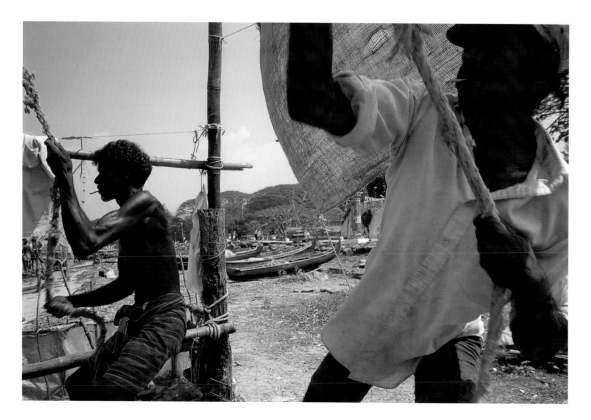

Feeling vulnerable as a lone female, I was hesitant when a fisherman asked if I wanted to go and meet his family. I sat in a cafe wondering what to do. I watched them haul in the nets. My head said no, but I was intrigued to see their lifestyles and my gut feeling said yes, so I went for it. I only slightly regretted my decision to go along, when my legs went numb after balancing on the cross bar of his cycle for fifteen minutes along an unmade road. I received an overwhelming welcome from neighbours and friends who came out to greet me. He was very poor and lived with his family of four in a two room hut within the commune. They insisted on feeding me, after which I was taken to catch the bus. My gut feeling had been right! I took a risk but everything had turned out fine. I wouldn't have missed it for the world.

The river was a lazy alternative route to Varkala, and meeting up with some friends from Hampi was a pleasant surprise. The backwater trip was 'Shanti Shanti', six hours of pure bliss. Coconut and banana trees lined the river banks, schools of ducklings filed past us, and fishermen were undisturbed by a boat load of tourists curiously gazing at them.

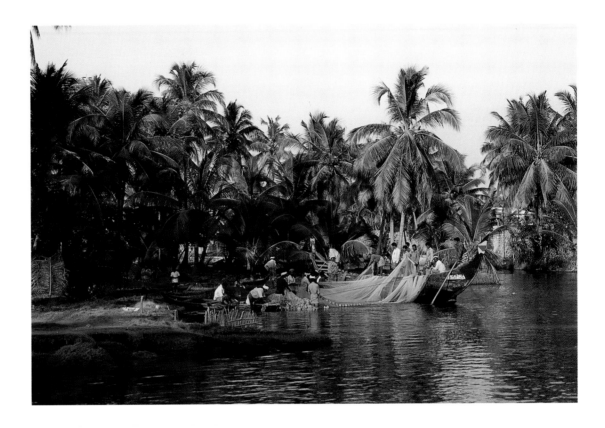

While we stopped off for lunch, I took a walk around. Behind the restaurant some women were spinning rope out of old coconut husks. None of them spoke any English, but we had a short conversation with sign and body language. They asked if I was married and had any children. I just patted my flat stomach and shook my head, which made them laugh. Leaving them to their spinning, I returned to the boat.

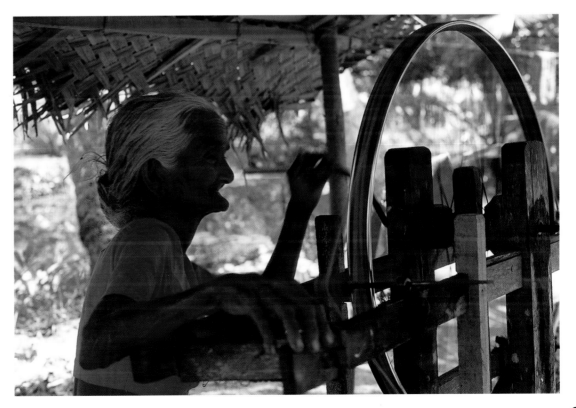

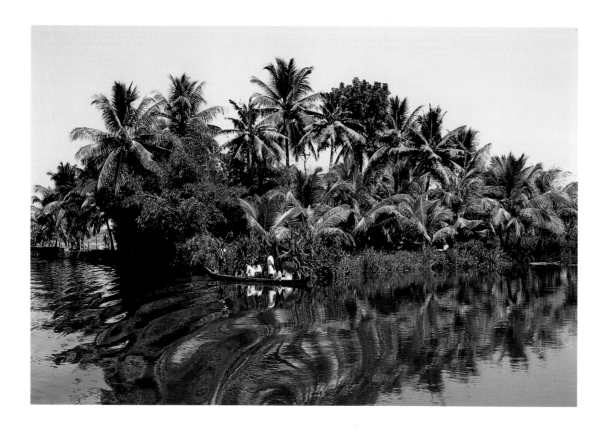

The boat stopped in the wide part of the estuary so we could go swimming. The men dived in, freely stripping off. The women were more reserved having more to expose. I sat sweating, wishing I'd worn a bra - I could bear it no longer and I knew if I didn't join the others I'd regret it later. Suppressing my inhibitions, I stripped off and dived in, only to be scared out by the mention of crocodiles!

The locals paused in their work to wave at us as we passed by. We cruised past prominent buildings and others hidden from view. The journey gave me time to think about what I was going to do next. I was heading to Sri Lanka, without a guide book or companion, and didn't know anything about the country. But watching people on the river banks living an isolated peaceful existence made me review my worries and just go with the flow.

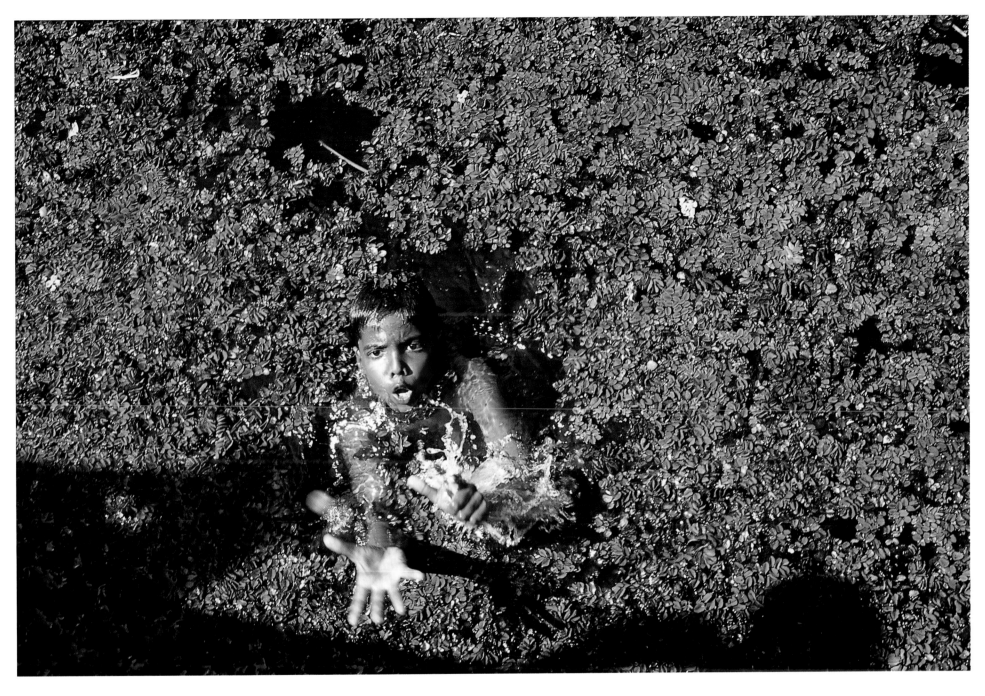

Children ran along the river banks, happily calling out to us and then diving into the water to retrieve coins thrown to them. Even away from the cities they have to earn a living, begging.

Sri Lanka

I'm in Sri Lanka. I can't believe it! The last couple of days have been so hectic that my feet have hardly touched the ground. It's funny how things have a way of working out.

My last night in India was quite amazing. One minute I was eating alone working out a rough plan for the month ahead. The next, I had a travel partner. A guy on the next table joined me for dinner and while we revealed our future plans, he made a mad decision to scrap his and join me. We spent the rest of the evening and most of the early morning drinking endless cups of coffee in the city bus stand, working out a plan of action. The flights were fully booked but we were determined to travel together. I flew out the following morning as planned, with vague arrangements to meet up in a day or so when he had managed to get a flight.

After spending three days waiting for my travel companion to arrive, I decided I couldn't wait any more. I got into mission mode and planned my next movements. While checking out train times, I turned around to see a familiar face looking dazed and confused. He had a rucksack on his back and bible (guide book) in hand. I realised it was my travel companion. A strange feeling of disbelief and excitement gave me a huge adrenaline rush, like a re-union with a long lost friend. He had just arrived off the flight. I could have been anywhere in the city at that moment in time. Fate had brought us together, the co-incidence of meeting like this was almost too good to be true, we were obviously meant to explore together.

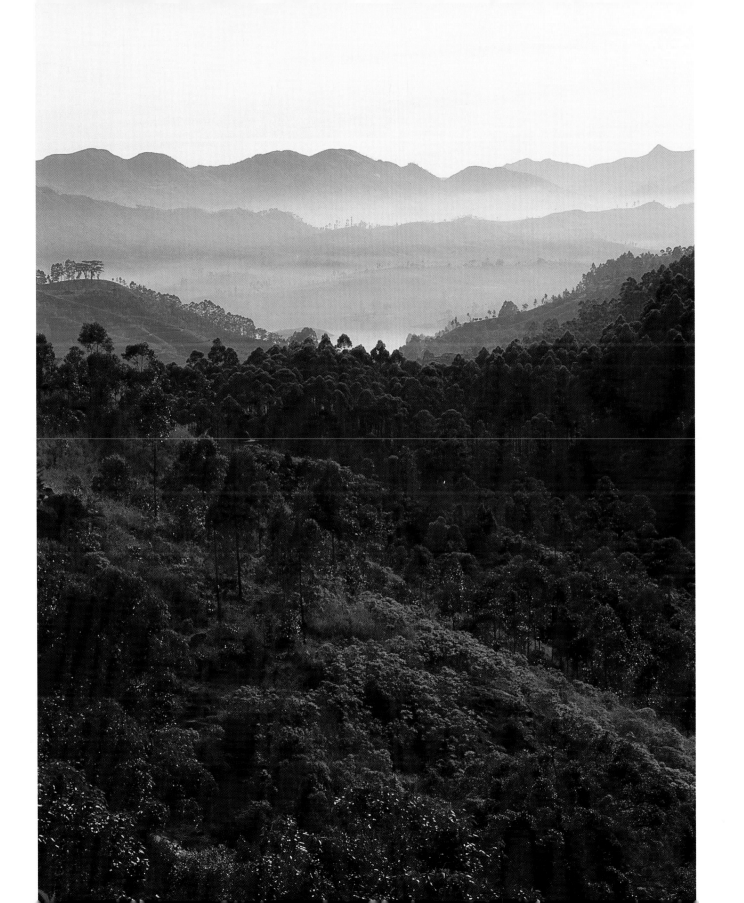

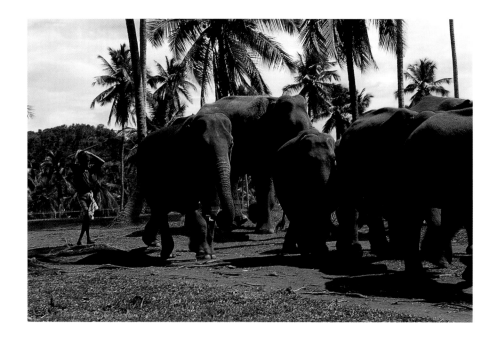

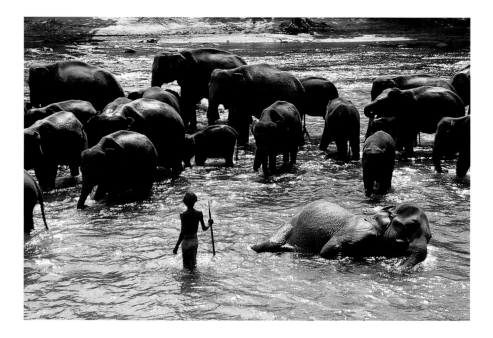

After relaxing for a few days in Kandy to acclimatise ourselves to the new country, we set off to sightsee. We hitched our way to the elephant orphanage, which was stuck out in the sticks. There were the expected tacky tourist shops selling elephant memorabilia, but away from the roadside the huge beasts roamed their park freely. We arrived in time to watch them plod down the street to the river. All sizes, from babies to granddads, heaved their huge bodies down the narrow lane. They could hardly wait to cool off.

Their gentle nature had no relation to their size. The herdsmen kept them under control, but paled into insignificance. We watched them for a while from the river banks, totally forgetting about the crowds of other tourists behind us. The bigger bulls had to roll over to cool themselves off in the shallow waters, lying like dead on one side before rolling over to cool off the other.

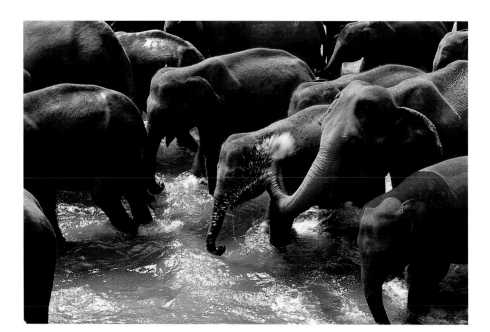

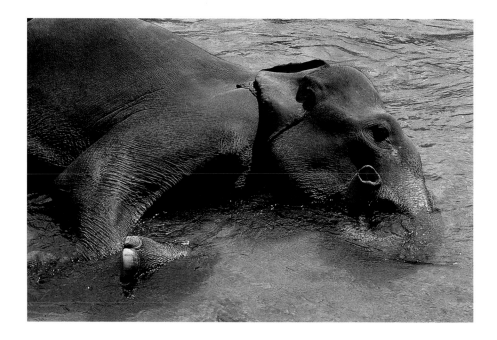

Following the advice of a fellow traveller, we visited the Diyaluma Falls. Although the falls were impressive, the view from the road was less than inspiring, so we followed his instructions and trekked to the top. The steep climb took its toll on my legs, but the effort was worth it.

The views over the plains and the rush of the water were perfect surroundings to relax in. We discovered a secluded rock pool that was overgrown with trees and vegetation, where we discarded our inhibitions, as well as our clothes, and jumped in to cool off.

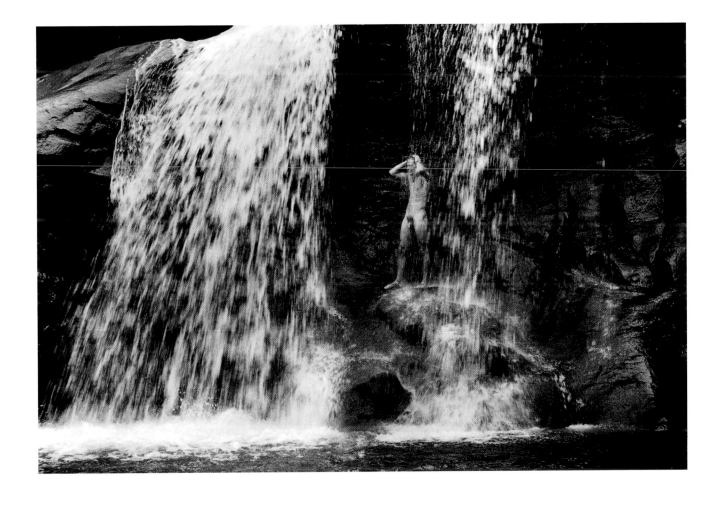

Being unable to speak or read Sinhalese we asked a local which bus we should board. Luckily for us, he spoke English and was going in the same direction. When the bus arrived he beckoned for us to follow. We heaved our heavy rucksacks onto our backs and clambered on. Before we had had time to find our seats, he had paid for our fare and expected nothing from us - not even a conversation.

Kept awake by a distant chorus of chanting, we decided to investigate. We donned our clothes, grabbed a torch and set out in the direction of the voices, which were echoing around the valley. We followed various paths through gardens, back yards and along railway tracks until we saw a house in the distance lit up like a Christmas tree. Wondering cumbersomely in the darkness down through steep tree plantations and over brooks, we eventually reached the house. We were immediately invited in and greeted with a warm welcome. The main room was packed with people passing around a cotton thread above their heads. This led to a small shrine, where Buddhist monks were reciting Mantras, raising the spirits of the deceased who had passed away a year before. We were shown around the house, introduced to everyone and fed bananas, biscuits and tea. Not wanting to disturb the proceedings any further, we set off back to our lodgings. Our path was lit by the full moon. The singing and chanting followed us back up the valley. When we awoke they were still going for it.

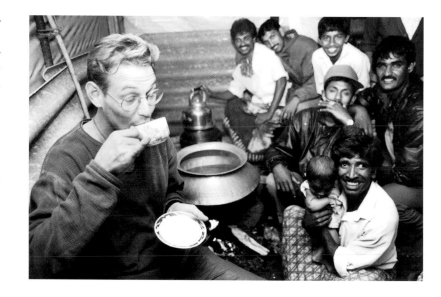

We got up early after barely two hours sleep, and headed for the bus stand. Being on Asia time we had to wait a while for the bus, so sat around and watched the world go by. We found a spot away from the crowds. The lingering smells from the food stalls and diesel fumes engulfed us. We listened to a busker playing a type of drum which I wanted to buy. He gave us the address of a drum maker and we set off on a mission with the scrap of paper in hand.

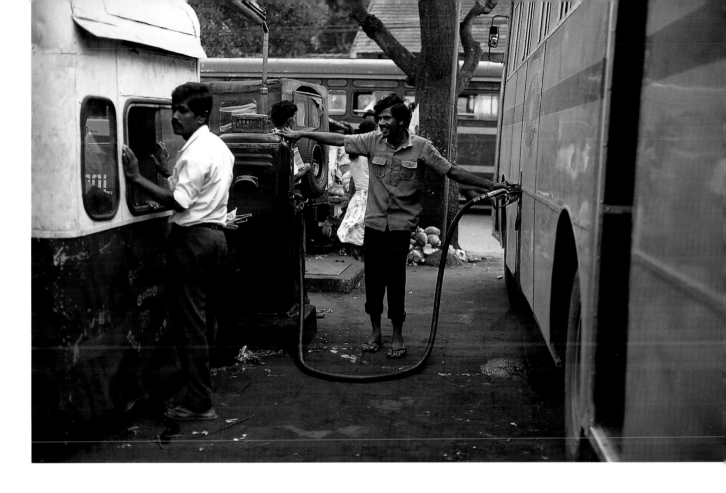

Squashed like sardines on the bus, I managed to catch sight of the name of the town we were passing through that corresponded to the name on my scrap of paper. We spontaneously jumped off and headed for the Post Office. The post master sent us off with vague directions and we headed down the road, getting strange looks from the locals. This was not a regular drop off point for tourists.

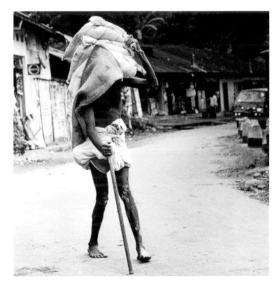

After walking a sweaty couple of kilometres in the midday sun, we realised our mission was a long way off. We left our bags at a house and set off again fifteen kilos lighter. Directions were getting vaguer and no-one spoke English. The road turned into a dirt track, and the looks we were attracting implied few or no Westerners had been here before. It was all fairly exciting, unsure of our whereabouts and not knowing our destination.

69

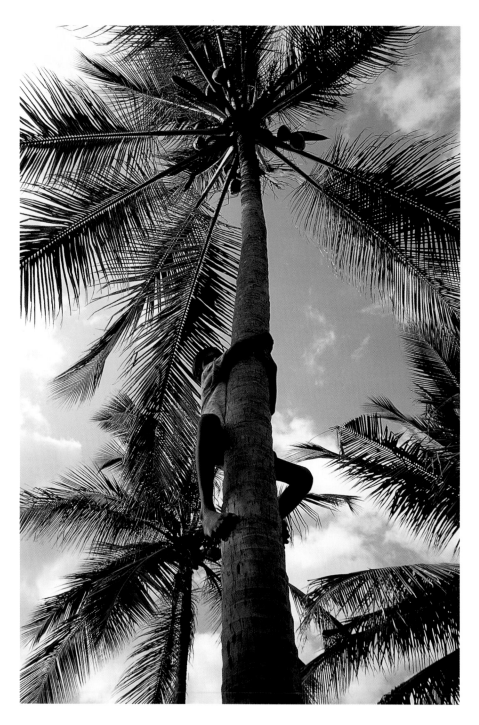

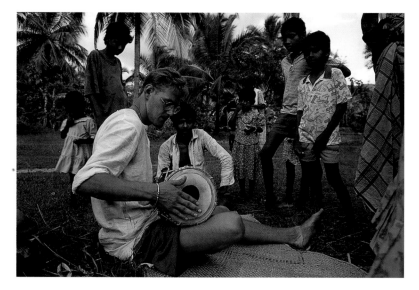

Word spread of our arrival, and neighbours and friends appeared. We managed to communicate through sign language. A drum was brought out and singing and laughter passed away the hours.

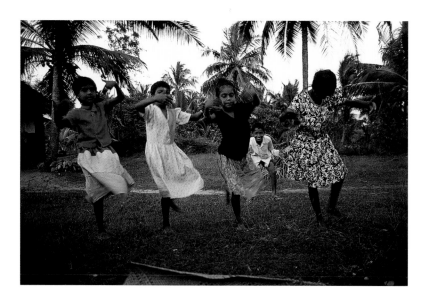

The lane went on and on. Luckily a guy on a bike stopped to offer us a lift. We sped off deep into the jungle, occasionally stopping to ask directions. Three on a moped along an unmade lane gave the suspension a hammering. The lane thinned to a ragged path, and we eventually came to a small cluster of mud huts. The drum maker wasn't home, but his wife was. She gave us a warm welcome and despite being unable to speak any English she convinced us to wait. A young boy was sent up a nearby palm tree to fetch a coconut whose milk we drank straight from the shell.

We were surprised when the busker, who had given us the address, turned up. He had given us his own address and wanted to take us to the drum factory himself. The party carried on through the night; it was as if they had decided to celebrate us being there.

Next morning we were up with the cockerels. I tried washing in a sarong but found it impossible, so stripped off in the loo. Inquisitive to see how our bodies compared, his wife stood outside the door, passing in endless buckets of water to me while trying to catch a glimpse of my naked body. We built up a strong friendship in a short time and leaving was difficult. She followed us down the lane and watched us disappear over the paddy fields, waving until we were out of sight.

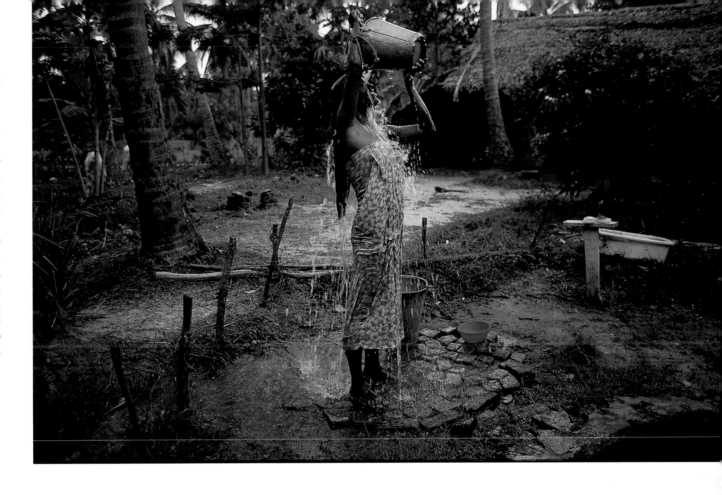

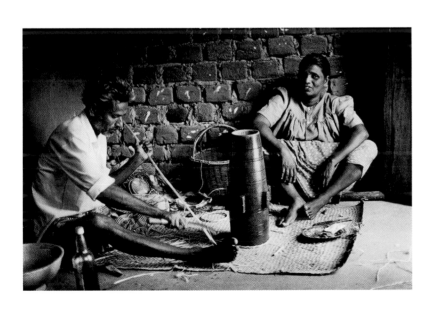

We followed our guide deeper into the wilderness, zig zagging through paddy fields and plantations. Eventually we arrived at the factory, a small isolated house surrounded by open fields. After negotiating a price with the drum maker he got straight to work. The afternoon drifted by as we watched our drums being made, and marvelled at his skill of fine tuning them with his simple tools.

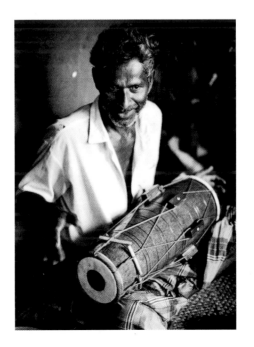

After many thanks, we left. With a drum under an arm, each banging away out of rhythm and getting strange looks from passers by.

Back on the tourist trail, our next aim was to climb Adams Peak, a popular pilgrimage with spectacular views over Sri Lanka. We set off at around 2.00am, to catch the sunrise from the summit. It was dark and cold and we were still half asleep. We set ourselves a steady pace which soon slowed as the steps got steeper and the growing crowds of tourists and pilgrims blocked our path. The route, lit up with fairy lights, snaked its way around the peak, and was lined with cafes and trinket stalls, blaring Hindi music from their stereos. Having expected a peaceful trek, the holy walk was disappointing, but it was easy to see why the pilgrims made the trip a dozen times or more. The view took our breath away.

The peak was super crowded. Everyone was facing east, gazing in complete silence, as the sun rose above the horizon. A monastery sat perfectly on the small plateau. The monks woke up to this incredible sight every morning - a rich reward for living such a simple life.

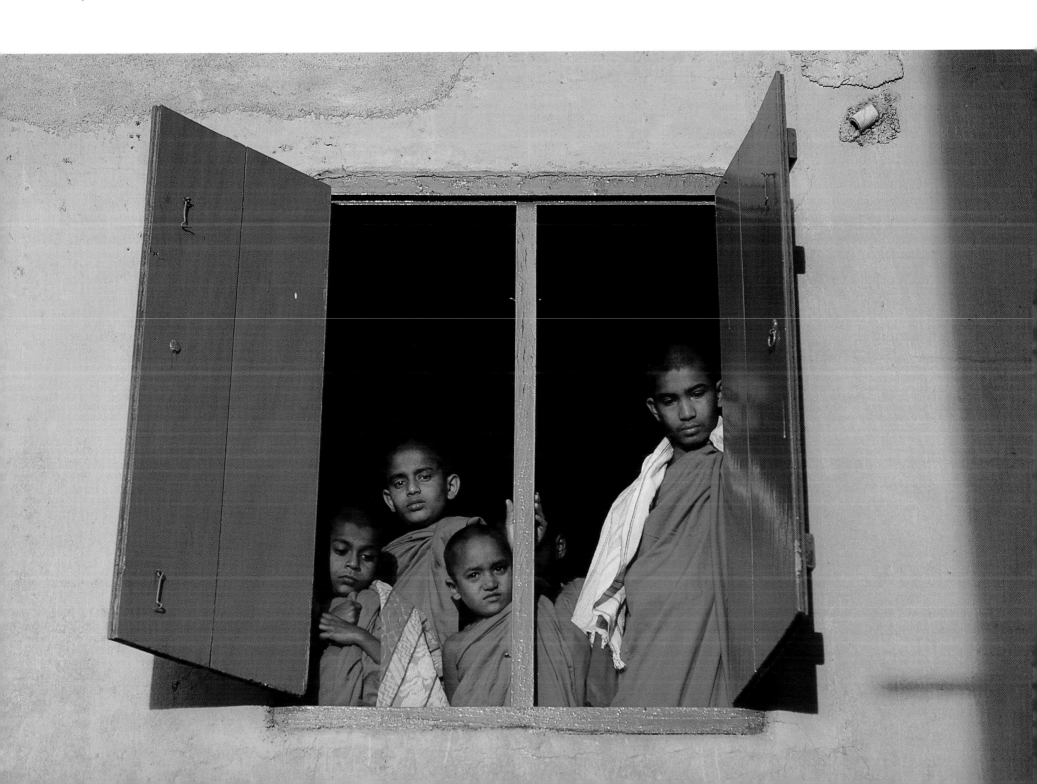

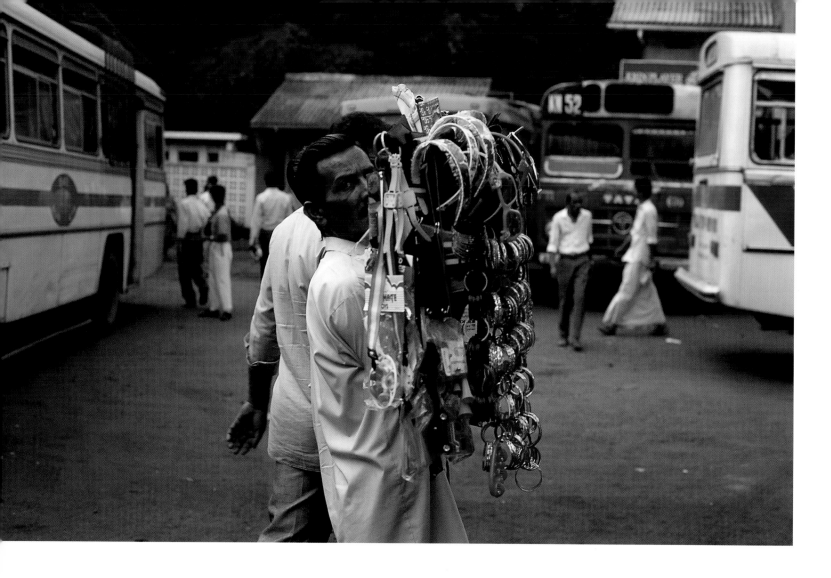

On one trip we were heading east in search of a beach. Unable to avoid the war zone, we passed through barracks manned with machine guns and over no mans land. It felt eerie. Our hearts stopped every time armed guards boarded the bus to search the passengers at the endless army check posts along the way. We were happy to relax on a completely secluded beach for a few days and recover from the shock of seeing the seriousness of the situation at such close proximity.

In the chaos caused by confusing time-tables, we spent as many hours in bus stations as on the buses. The boredom of waiting for connections was filled by watching the constant activity, including bus to bus salesmen offering anything from peanuts to plastic bangles. The bus journeys often turned into adventures in their own right, and being able to share the experience took away the discomfort of cramped conditions.

It was difficult to imagine a war going on behind these peaceful scenes. The locals lived with it and accepted it. For us it was time to move on. We went our separate ways, carrying with us a memory of the month's adventures, and looking forward to the ones that lay ahead.

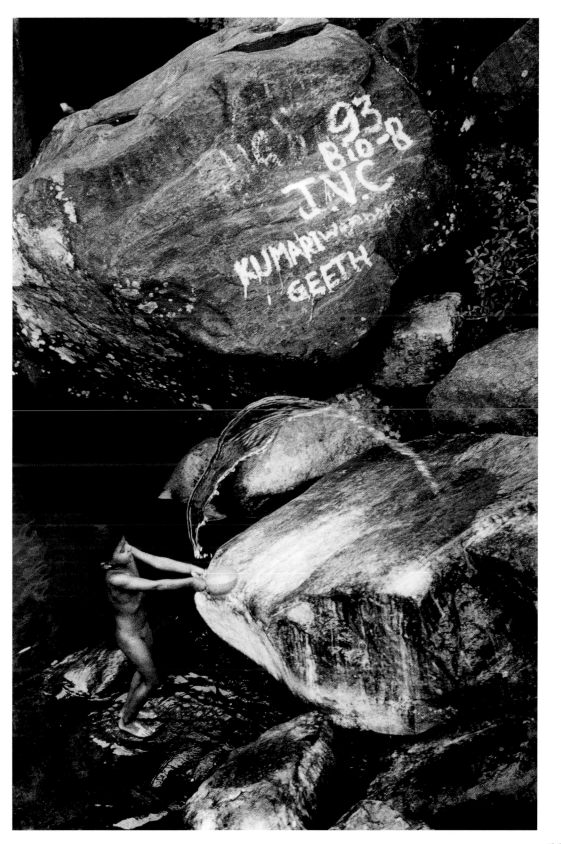

Thailand

Having spent so much time in India, I found myself missing it. Thailand was so much more expensive, and the burgeoning tourist industry totally threw me. Tours here, tours there, tours everywhere. It seemed all too easy. The biggest obstacle was the language barrier, apart from "hello" "thank-you" and "how much", my Thai vocabulary was very limited. Although at first very disorientated, I must have adjusted quickly because a planned months stay turned into two months.

I stood dazed outside Bangkok Airport, wondering how I was going to get into the city. No guide, no friends, just me and my rucksack. I spotted three people climbing into a taxi and I whizzed off down the pavement towards them, skidding my trolley to a halt. Without much approval, I chucked my rucksack across the lap of the two girls in the back, clambered in, introduced myself and we headed off into the city.

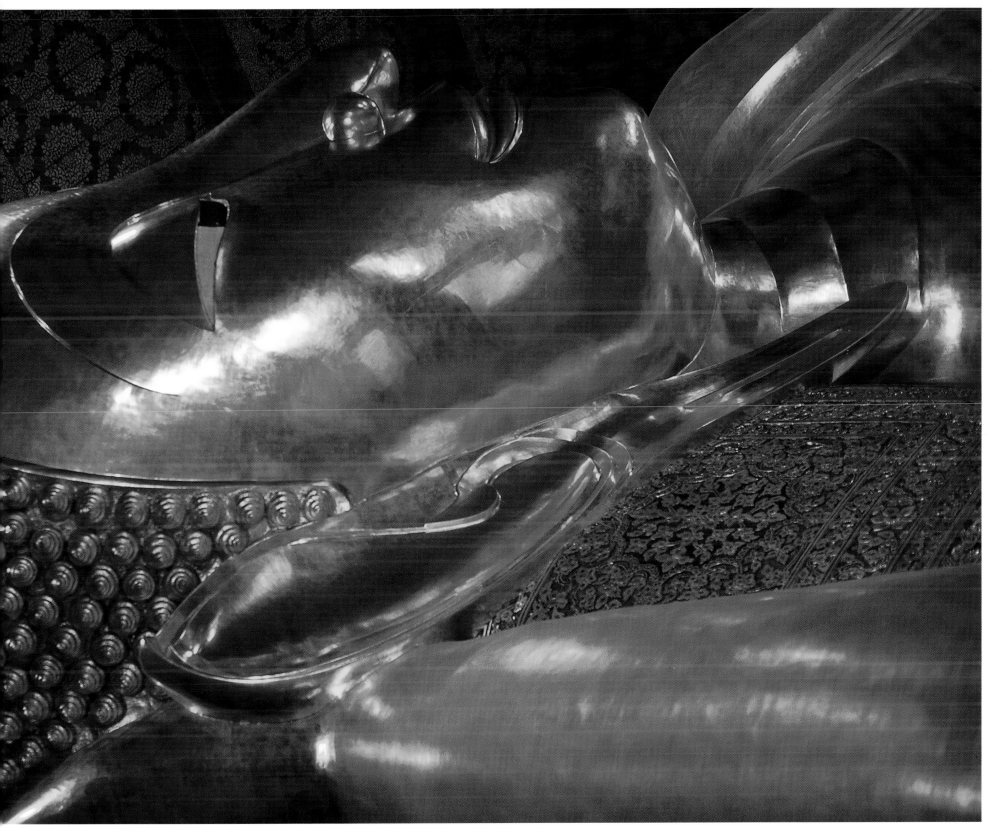

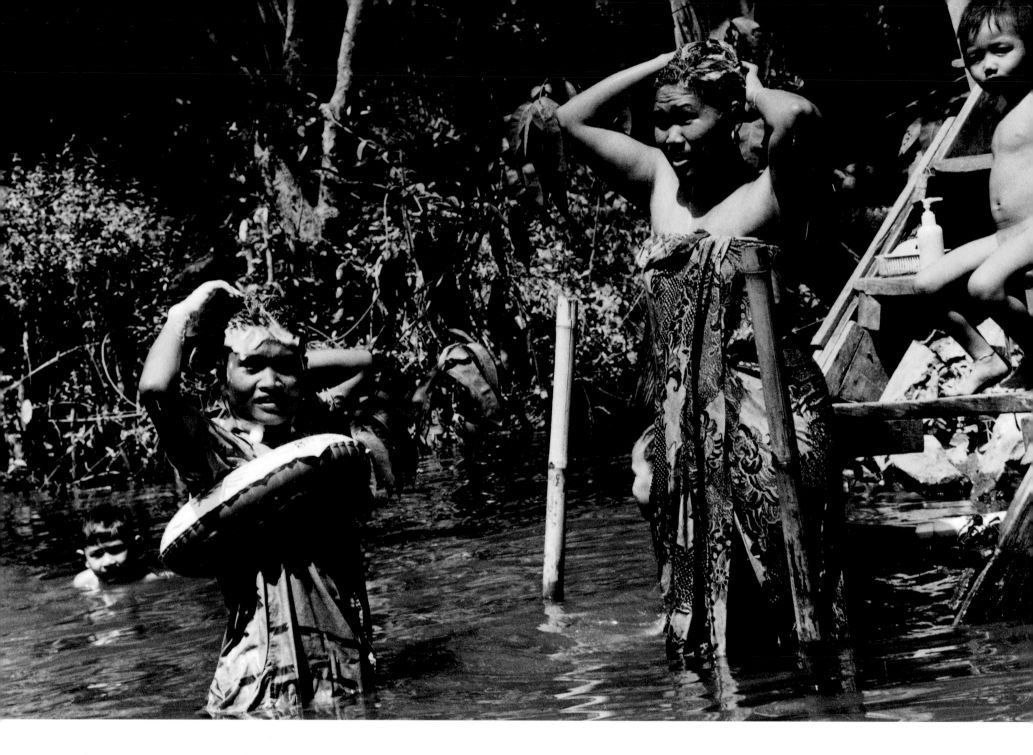

Not wanting to pay the over-inflated tourist price for a river trip, I went in search of the locals river taxi. I found one and hopped aboard. We passed stilt houses along the river bank. People washing or relaxing on their verandas. It was a lazy and refreshing hour-long trip, away from the smoggy traffic-choked city. We stopped at colourful temples for monks to board and disembark. We passed floating shops, which old Thais paddled from house to house selling their wares and a Walls ice cream man paddling his canoe up river with a fridge full of ice cream.

Too hot to do anything.

Opting as usual for the street food stalls - not only to save bucks, but also to get away from the masses of Western bars - I was faced with dry roasted grasshoppers, chickens' feet, pigs' trotter, tail or snout, and an assortment of delicately prepared cockroaches. Being vegetarian I stuck to the noodles.

Hmmmm, squid flavoured with smoky exhaust fumes!

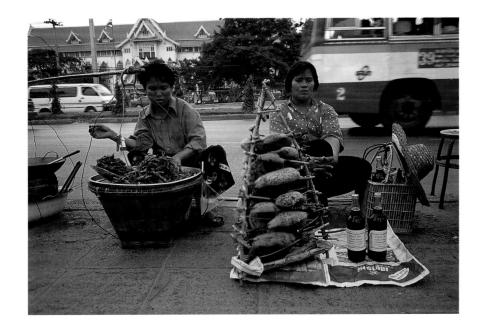

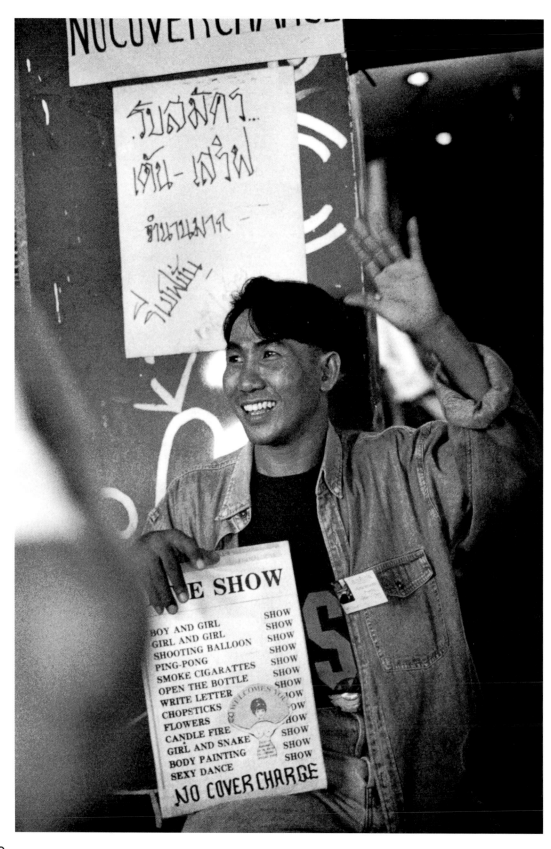

If you wanted to pick up a fake Rolex or a Thai girl - Pat Pong was the place to be. I wanted neither but ended up there. Touts in every bar doorway beckoned us in, showing off their extensive menus and offering free drinks. Sitting ringside to the stage I watched the circus acts in disbelief. I wondered not only what I was doing there, but where to look, and found watching the other patrons to the Go-Go bar far more entertaining. A few stools down the bar, an elderly guy looked incredibly bored by the antics going on. His expression soon changed when two Thai girls got friendly with him. An American guy sat down beside us and introduced his Thai wife. Seconds later he disappeared into a back room with her! I'd seen enough and made a quick exit.

It seemed everyone in Bangkok was wheeling and dealing, ducking and diving to survive. Everything was on offer, from forged travellers cheques to work as a film extra. I turned down an offer of eight hundred dollars for a days work to appear topless in a karaoke video. Instead I headed North to go trekking. Choosing a trek was pot luck. The unlimited variety made decision-making confusing, as all tours declared that theirs was the best. I was fortunate to choose a trek that was small in numbers and big in personality, with a broad range of nationalities. Our guide was called French Fry, a woman with a deep voice, hands and feet of a man, and a scar left from the removal of an Adams Apple!

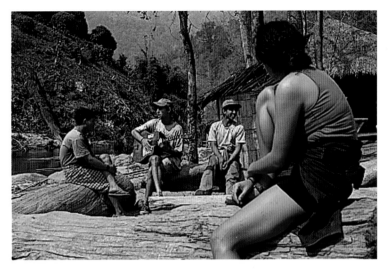

We clicked well as a group and encouraged each others individuality. While I was busy preparing supper with the local women, others interacted with the locals by entertaining.

It was great to be out in the smog free zone. As the minutes turned into hours of walking, chatting and joking soon petered out. The sounds of the jungle were muffled by our heavy breathing and plodding of feet.

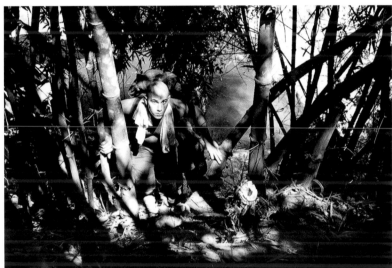

We woke up as stiff as the boards we had slept on, and to the tuneless cries of cockerels. We donned our boots and set off deep into the jungle. The elephants gave our legs a break in the afternoon, taking us to our next camp. They then cooled themselves off in the river as we washed away the regurgitated water that had been sprayed all over us from their trunks during the joy ride.

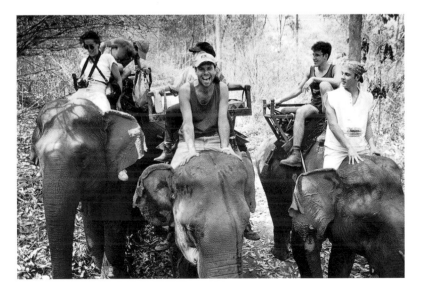

Hoping perhaps to be the first white faces the hill tribes had seen, we were disappointed when villagers had obviously seen hundreds of tourists pass this way before. The kids were shy, but quite used to trekkers and bonded with us quickly. They entertained us in the evening with well rehearsed songs, our only contribution being 'She'll be coming round the mountain'.

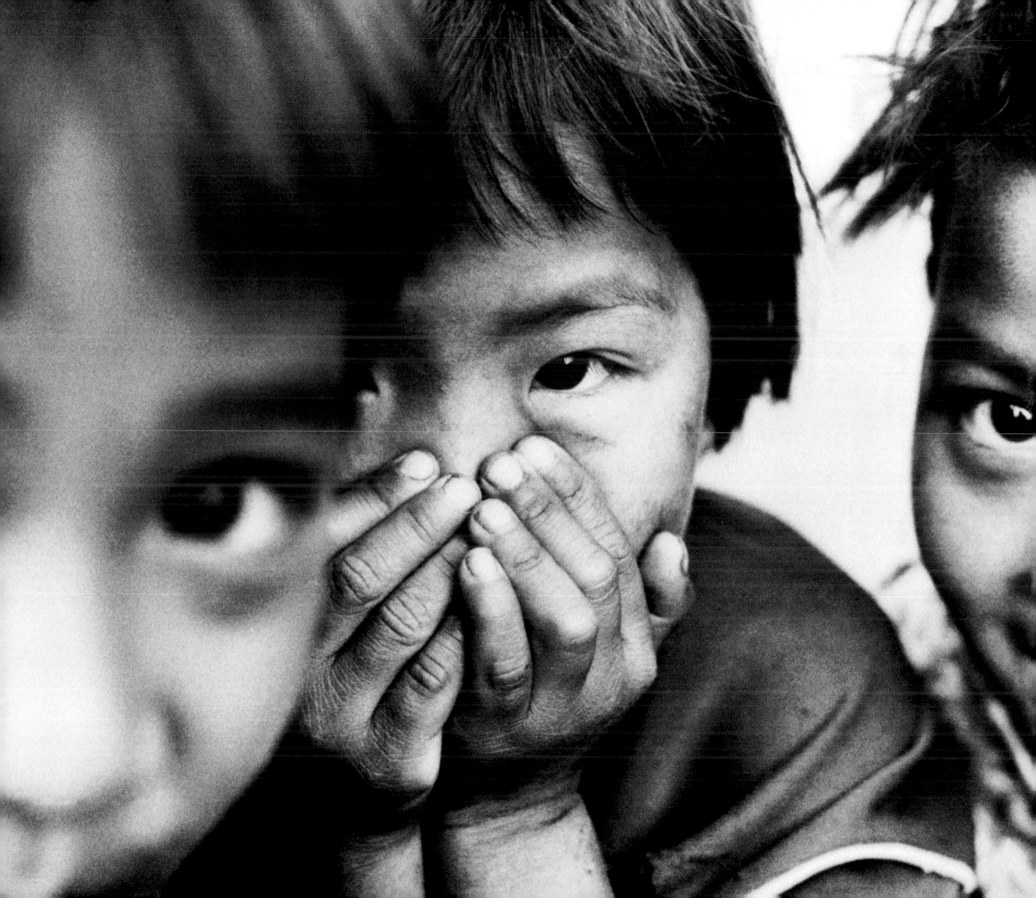

An old Thai guy stood by to stoke up the fire while we sat under the stars and discovered each others' hopes, dreams and past experiences. Inside, 'Doctor Opium' was lying down preparing his pipe. One by one everyone took turns to go in and sample the sweet tasting, mind-altering fumes, returning to the fire with glazed eyes and a broad grin.

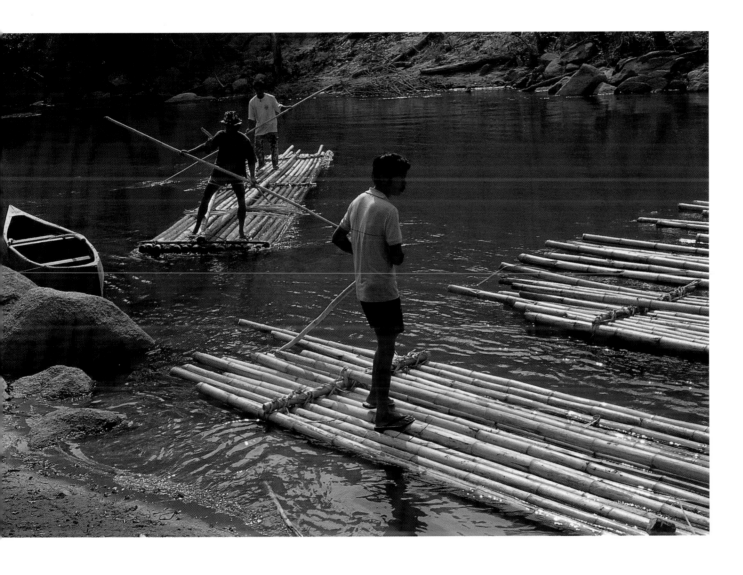

The thrilling white water rapids we had been promised were scarce. The trip consisted more of races and water fights, and was brought to a hilarious halt with the collapse of the loosely-strung-together bamboo rafts. The trek had been overrated, but the friendships made were worth every penny.

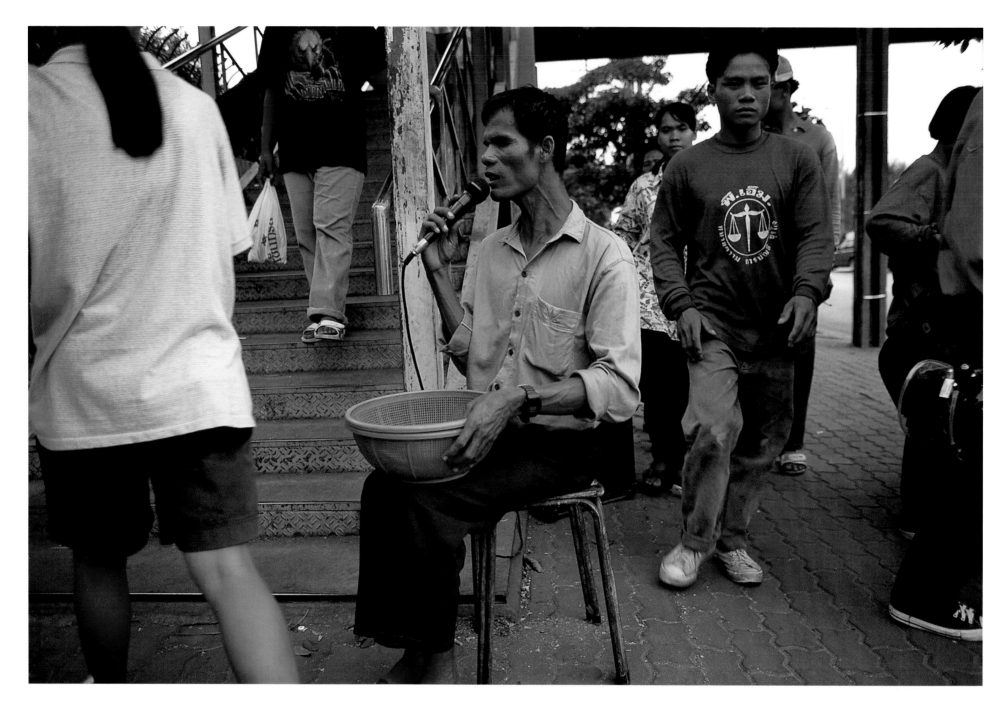

If it wasn't for modern technology, this blind beggar could not be heard over the roar of the traffic.

I was back in Bangkok but I wanted to be as far away from it as possible for the expense of everything was burning a hole in my pocket, and the atmosphere was suffocating. I got on with my necessary missions - Changing money, picking up mail and rearranging my flight schedule. I quickly moved on.

I got a garbled message from my mum to meet a friend on an island. I headed to Ko Pha Ngan in search of him, making a thirteen hour detour to pick up mail from Phuket (my original destination). Scouring the countless beaches, I had virtually given up when I bumped into him.

Cooling off in the sea later, I also bumped into some friends I had travelled with in India. "There are no accidents in life" said one practicing Buddhist. We had made no plans or ties to meet up, fate had brought us together. The next four weeks were one big party.

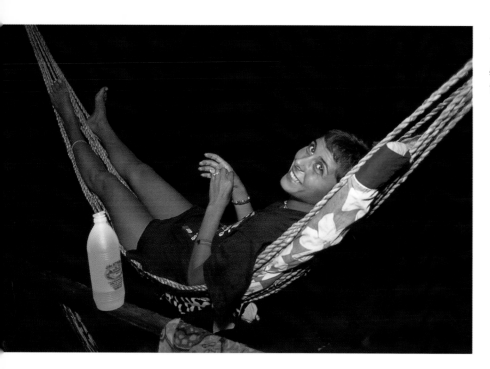

The dance parties started in the early hours. Some got a few hours sleep beforehand, some were unable to. Others spent time waiting for the party to start, chilling out and trying to conserve energy before they kick off.

The images that had been created were moving before my eyes. Patterns changing, and even dimensions. Dancers whizzed by and strutted towards me, their intense expressions cracking me up. At one stage I was convinced I was surrounded by dancing horses and fell into fits of giggles. The hypnotic beats took me over the edge.

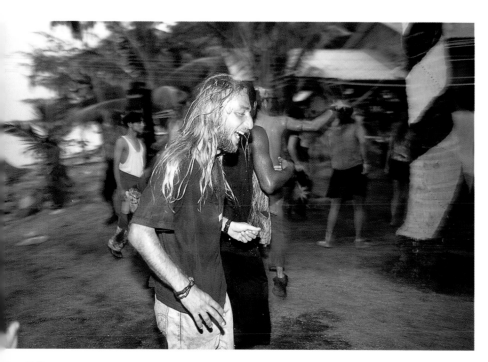

It seemed everyone knew each other, and as a newcomer I somehow had to fit in. At first I was self conscious. But as my barriers came down, I relaxed and realised that everyone else, however long they had been there were only too happy to meet someone new. The key is to just let yourself go. No-one knows who you are or where you come from. There are no expectations or standards to live up to. You can be who you want, with whoever you want, when you want, and people did just that.

No-one escaped a drenching during the Songkran Festival (the water fights lasted for three days). This marked the driest part of the year as well as seeing in the Thai New Year. You couldn't so much as walk out of your bungalow without a bucket of water being thrown in your face or over your back. But at the end of a long night dancing it was a fun way to cool down.

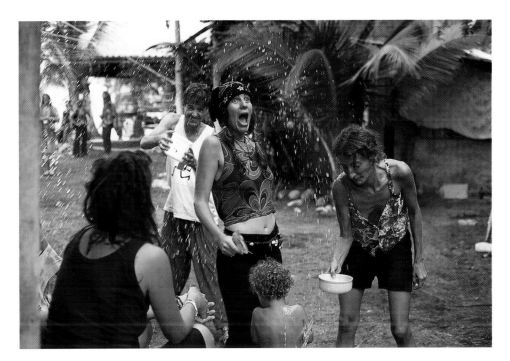

Organisers spent days preparing the visuals for the parties. A luminous wire was connected in spiral webs from chalet to chalet. Trees and people were painted. Even the dogs were painted to stop people tripping over them as they ran around your feet in the darkness.

My head was still buzzing after the party, but my body told me to stop. I bade the sea good morning with a refreshing swim. Floating with my ears beneath the water in complete silence, I felt completely relaxed. Getting out, I had a massage with an old Thai guy who had been dancing with us a few hours before. Laid on a beach, under the shadow of a palm, the sea lapping up the shore, I was in heaven. His ancient hands felt like floured dough, as they massaged my body methodically, washing my tension away with the waves behind. My body tingled when I awoke.

Sumatra
INDONESIA

I'm silently freaking out about going solo and travelling alone through Indonesia. My stomach is churning and I'm having anxiety attacks over the simplest things. Catching a bus seems the hardest thing in the world at the moment. Which bus? Where to? And what to do when I get to wherever? I was so excited about what adventures lay ahead but now am having second thoughts due to hearing a number of different horror stories from various females with experience. It would be so much easier to go back to the countries that I know and love and feel safe in. But then I may never know, or experience for myself what might have been. My mind is running riot in all directions. I decided that all this bad energy I was creating from my state of mind, would only attract bad things. I put on my positive head and went with my heart. Fate up until now had brought me this far, nothing was going to go wrong.

Having travelled briefly through Malaysia from Thailand, I took the Catamaran from Penang to Sumatra and arrived in Medan dazed and dehydrated, after throwing up half a dozen times during the four hour crossing. The local touts took advantage of our confusion over the time change by telling us the buses had stopped running, and they whisked us off to their hotels. I had no wish to stay in the city, so escaped to the rain forests the following morning.

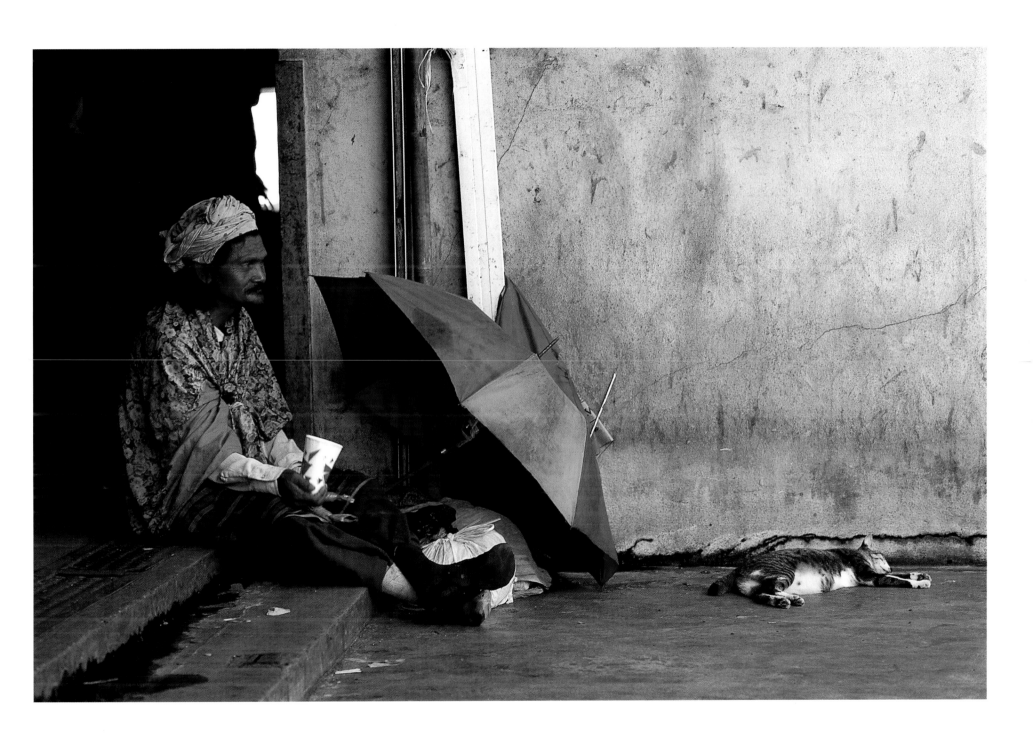

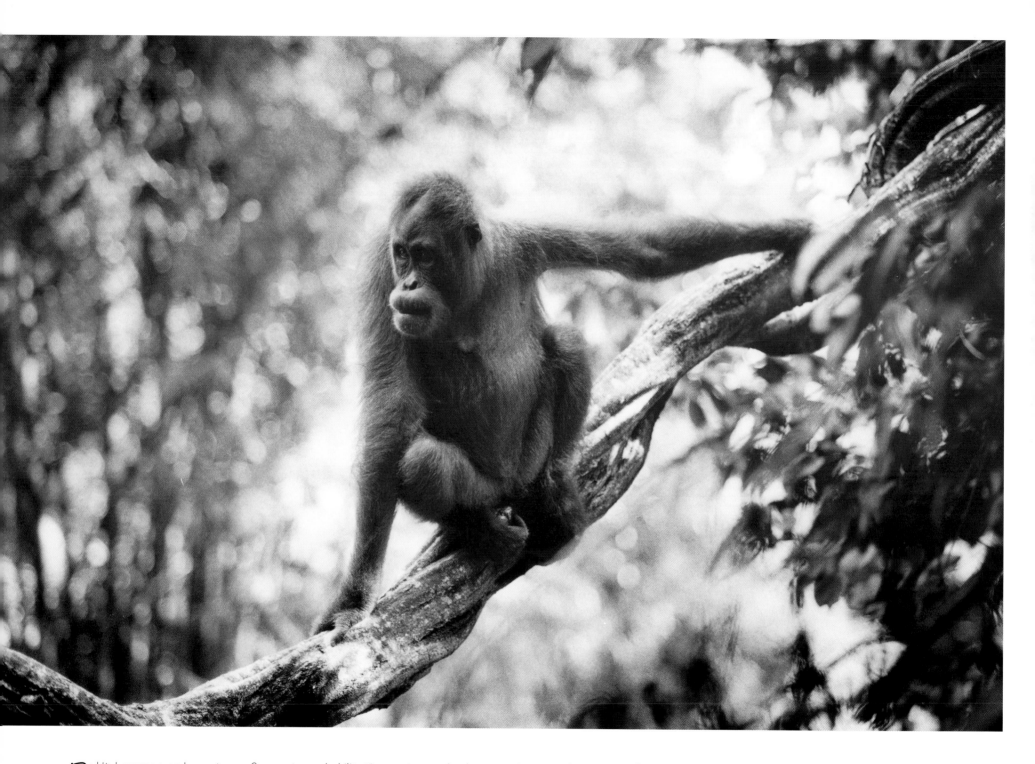

Bukit Lawang was home to an Orang-utan rehabilitation centre, and a busy tourist spot. Visiting the Orang-utans in the wild was a breathtaking experience. Breaking branches overhead gave away their movements in the tree tops and some even came down for a closer look. But the huge influx of day trippers caused an irritating distraction. The Orang-u'tans' even showed their resentment to the crowd, by excreting on us from a great height.

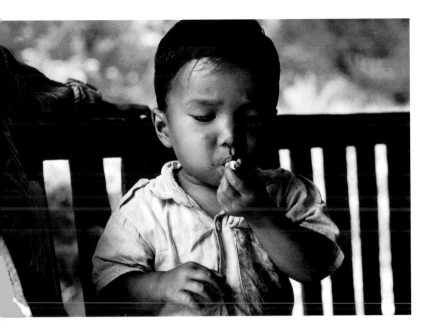

My plans were to move swiftly on through the Islands of Indonesia to Australia. The two month visa gave me little time to hang around so I moved on swiftly to Lake Toba. Arriving at the harbour, I was more than annoyed that I had been followed by an Indonesian guy from the hotel I had just come from and made it quite clear I was meeting my boyfriend (a small fib which thankfully got rid of him). It was a minor hiccup which I soon forgot when I got to Samosir Island.

Captivated by the local scenes and awesome views, I spent almost a week cycling around the island and hanging out with the locals. A concerning sight was this two year old taking a lung full of nicotine. His father, amused at my health warnings, merely sat back and looked on proudly at his son.

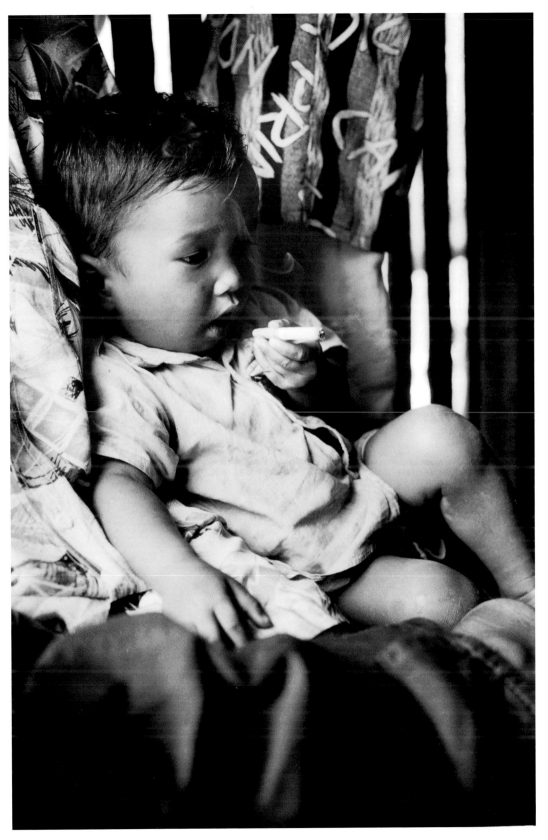

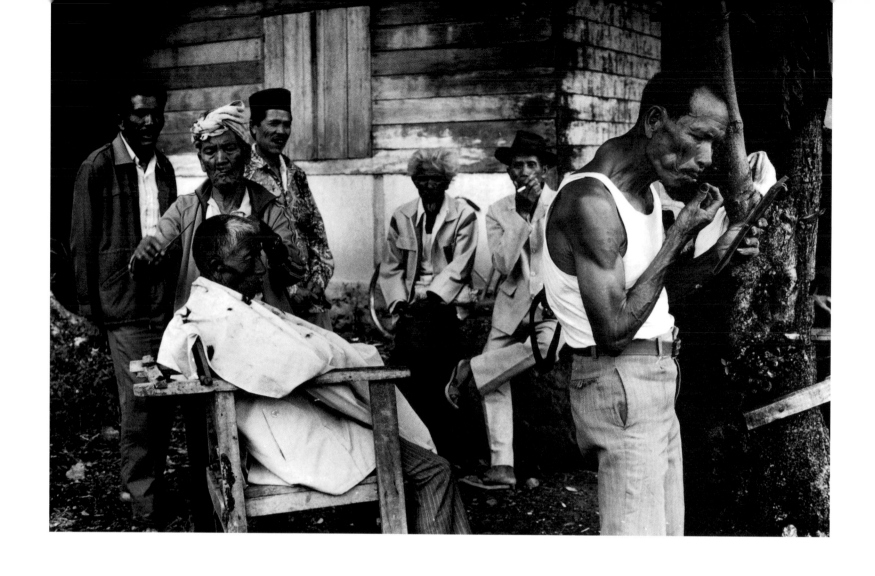

Barbers qualifications were owning a pair of scissors. It was a hair raising experience visiting one. The only consolation to having your precious locks hacked off with a pair of kitchen scissors was that a cut, massage and a shave cost less than 20 pence.

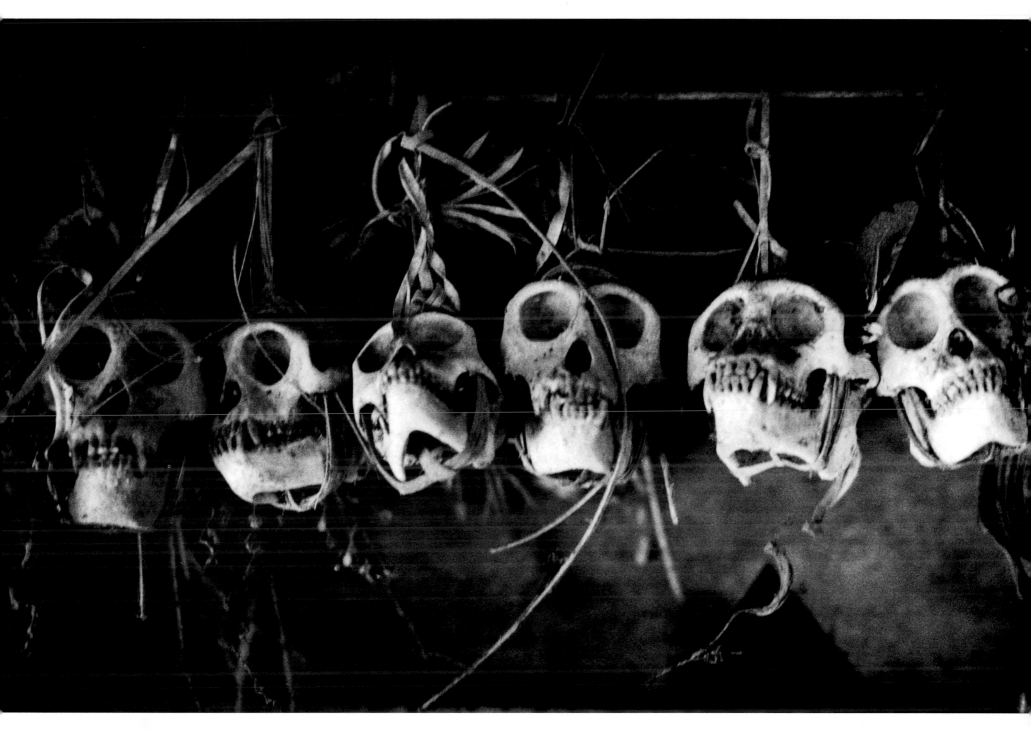

Cramped for nineteen hours on a bus, around hairpin bends that made my heart miss a few beats, I crossed the equator and arrived in Bukittinggi. I made a spontaneous decision to go on a trek and the next thing I knew I was on my way to the Jungle island of Siberut.

We stocked up with snacks and cigarettes and boarded our vessel settling ourselves into our supposed first class accommodation! Like chickens in a battery, we squashed into our bunks with only tiny portholes for ventilation and oversized cockroaches for company. We awoke to a spectacular sunrise and in the absence of a jetty, we had to disembark mid-ocean into unsteady dug-out canoes. The jungle adventure started here.

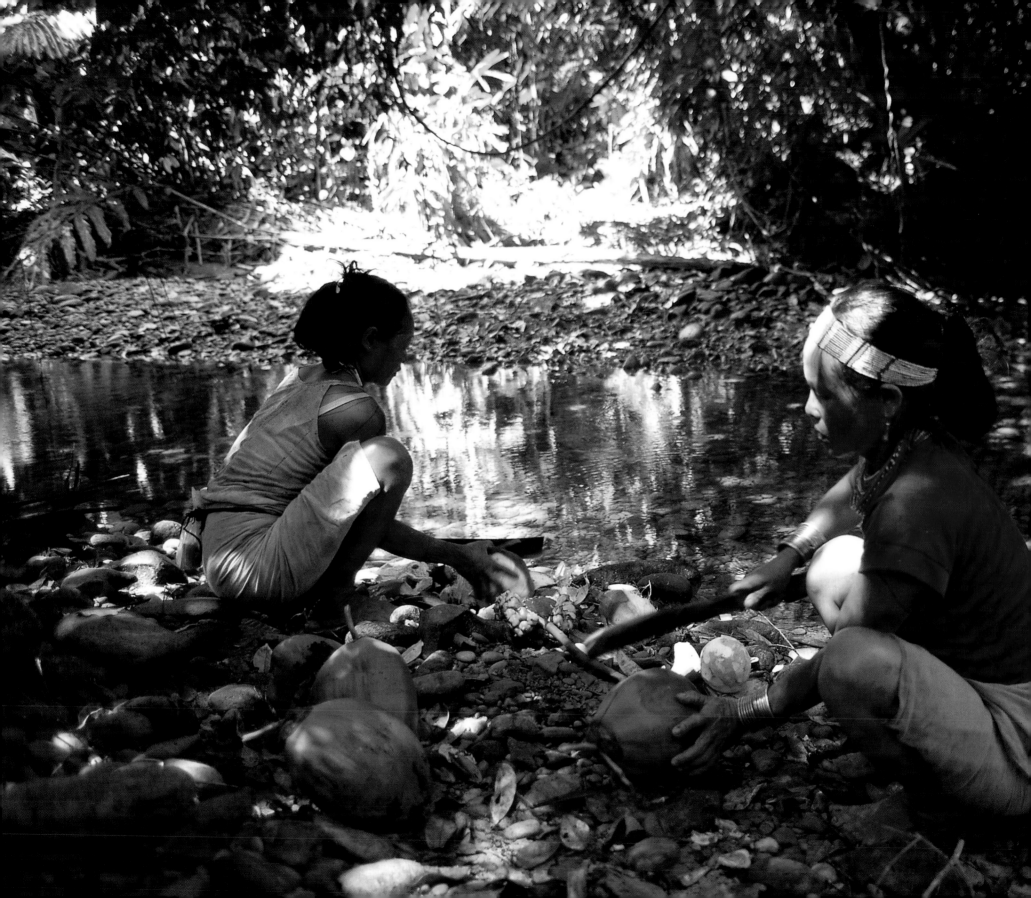

We were greeted by the locals with freshly picked coconuts and other jungle offerings and settled into our new surroundings.

The local dwellings were open plan, wooden constructions with uneven floorboards and a leaf tiled roof. Chickens and dogs ran wild through the house and pigs ate and slept below us. It didn't take long for the fleas and mosquitoes to detect our blood, puncturing our perfect skins and leaving their unsightly marks. After an uncomfortable nights sleep, everyone emerged bleary eyed from under their mosquito nets, relating to each other dreams of helicopters flying around them and then discovering a multitude of itchy bites.

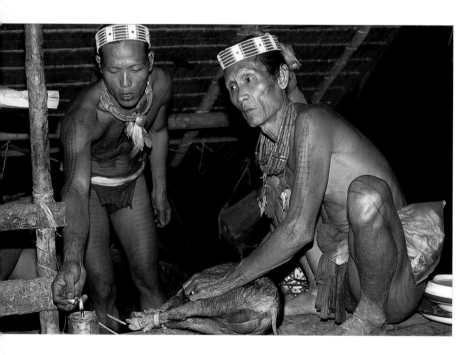

The locals made themselves backpacks out of vines, leaves and bamboo in less time than it took us to put ours on. Leading us to our next hamlet deeper into the jungle they moved quickly along muddy tracks, across slippery log bridges and through small streams. Our expensive trekking boots proved to be useless in this terrain, as I found out, slipping and landing head first into a family of stinging ants and spraining my ankle in the process. Paranoid of illness, together we had enough drug and emergency supplies to open a pharmacy and I was strapped up in no time. At sundown we reached our hamlet and settled down to an interesting evening of sacrifice. The children were completely detached from any feelings towards their pets being slaughtered before them.

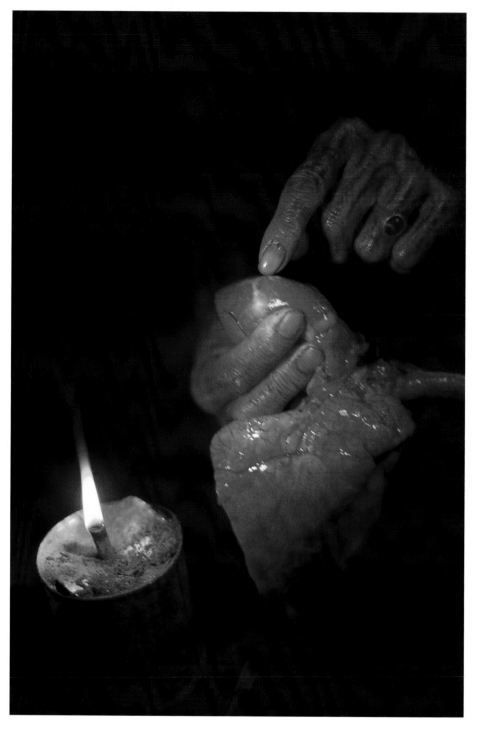

A small pig was caught for the sacrifice and gutted infront of us. Its heart was then cut out from which the future was read. It was a ceremony to honour good feeling and friendship.

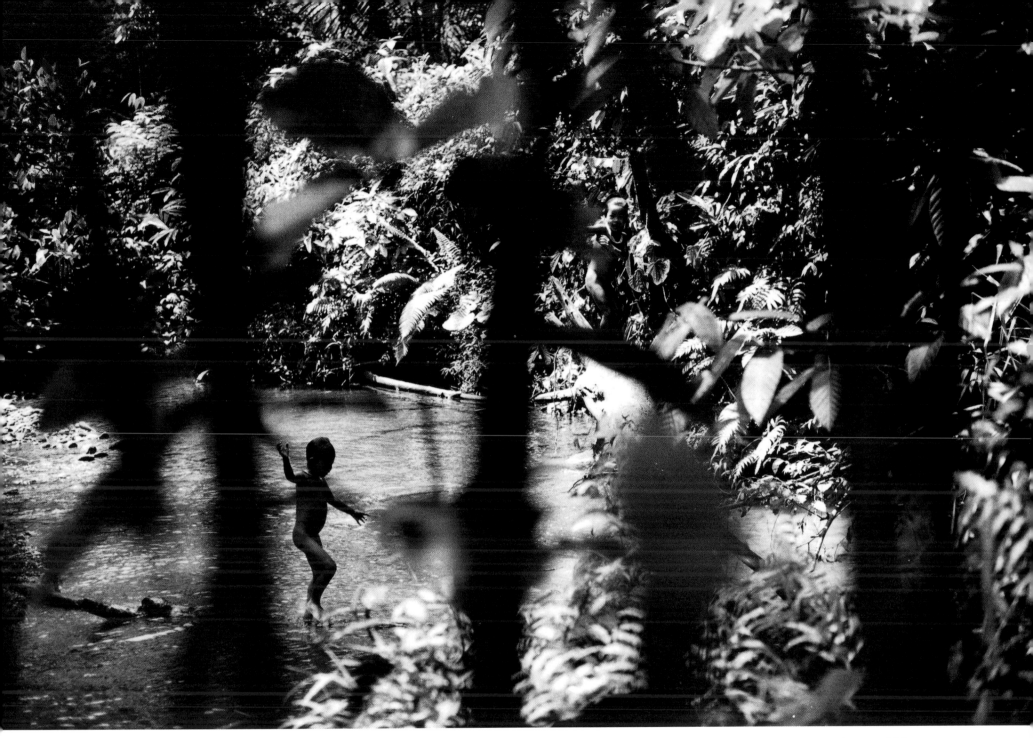

I decided to stay with a family for several weeks, or at least until the next trekking group came by to pick me up. As everyone packed up to return to civilization, I felt a mixture of emotions - as the last backpack disappeared over the river and into the jungle, I suddenly felt deserted, alone and out of place. The jungle was now my home. Cut off from all outside communication, I was a good eight hours hard walk away from civilization. But warmly welcomed and accepted into their lives, it was now up to me to fit in, find my role and learn the language.

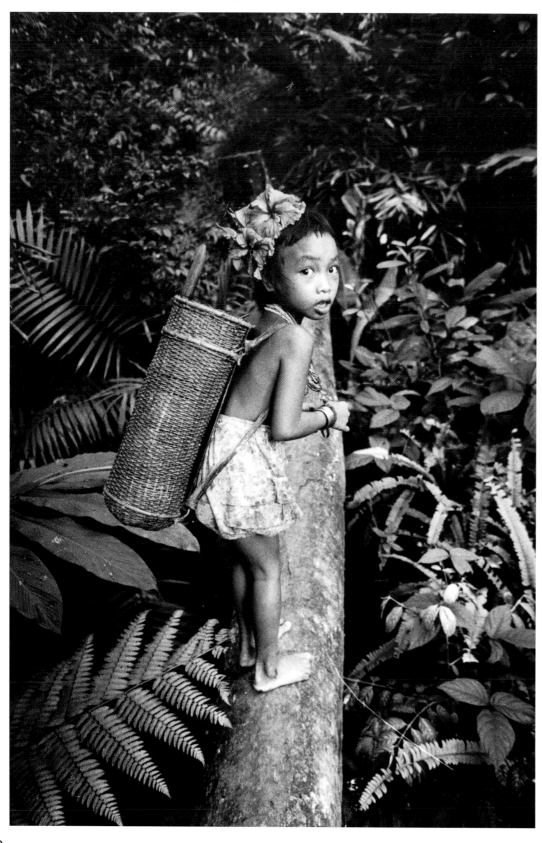

Deciding my boots were more of a hindrance than a help, I went barefoot and soon discovered what skill my toes had. "Grip with your toes" I constantly repeated in my head, until it became second nature. My newly adopted sister kept a watchful eye on me as we stepped across slippery logs. "Ow! Ow!" she warned, pointing to sharp thorns on the jungle floor as I approached them.

It was second nature to these jungle dwellers to carry out a spot of gardening en route. Maintenance of paths was undertaken on every outing, whether to collect firewood or visit a friend. Tools were part of every day clothing and consisted of a very large knife, this was used to slash back

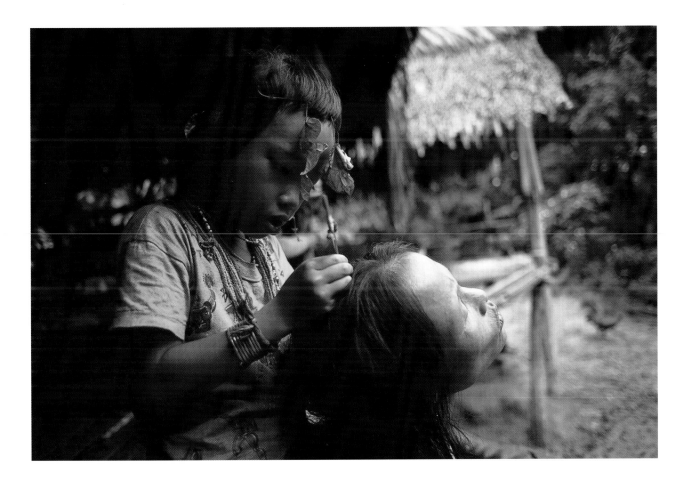

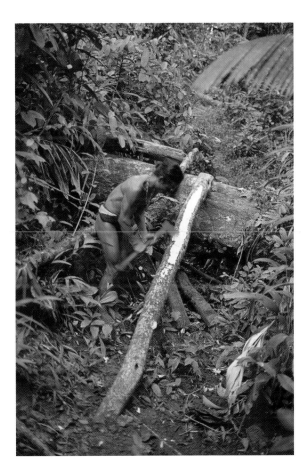

Hairdressing was a daily activity. When I was handed a pair of home made tweezers, I initially thought my job was to de-lice the family. It was a relief to find out I was being asked to pluck out Tatani's grey hairs. As the days turned into weeks, I was convinced she'd be bald before she turned grey, "No hair left" I joked, "No hair no problem" she replied. Vanity is obviously a universal preoccupation.

any overhanging foliage be it a branch, shrub or blade of grass. Their resourcefulness with the natural materials at hand was admirable - a giant log blocking our path was soon negotiated with a stepped ramp made from a near by tree. There was always something to be done and certainly no-one to employ to do it for them.

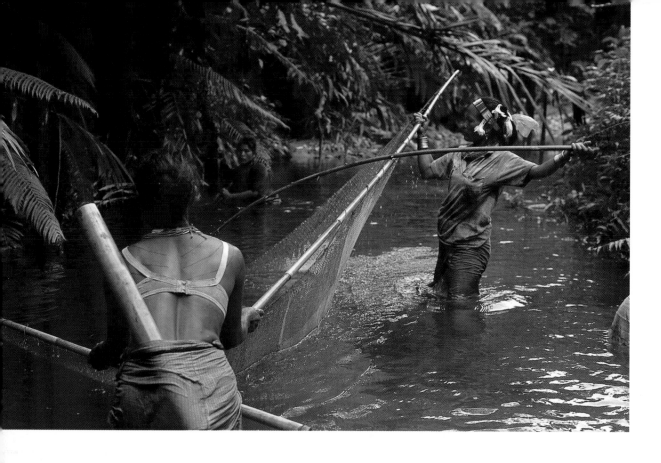

Fishing under the stars was a magical experience, waking up in the early hours to go wasn't. It was a fight between adjusting my body clock and eating, or sleeping and going hungry. Before I had time to wipe the sleepy dust from my eyes, I was handed the firewood to carry. My path was lit by a trail of burning embers falling to the floor from the fire torches held by the silhouetted figures in front of me. As we approached the river, still half asleep and unsteady on my feet, I hung behind so as not to stir up the mud. The water was waist deep at times but appeared translucent as the fire torches were swung low over the surface. The victim's eyes were lit up by the flames, giving away their invisibility. The women moved swiftly and silently through the water, like ballet dancers, scooping up shrimps in their nets. We trawled the river banks for hours, until the stars disappeared and were replaced by clear blue skies. We then made our way back to the house for a fresh breakfast and a long overdue sleep.

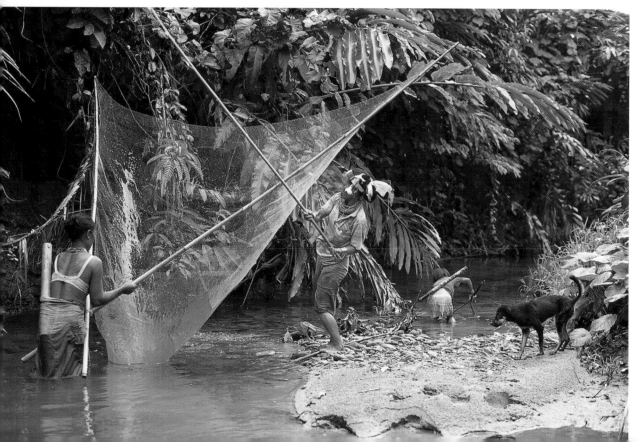

Fishing was women's work, men played no part in the activity except by helping to eat the catch. By day or by night it was a great excuse to meet up with the girls for a gossip. During the day, the small hand-held nets used for night fishing were replaced by a huge V-net construction. One of the women held the net below the water while the others dragged the water downstream chasing the fish into the waiting trap. Amid shrieks and cries, the net was raised, securing its prey. The younger members followed eagerly picking up tricks of the trade. It takes years of practice to master, but they made it look easy! Handed a small net, my desperate attempts to at least catch my share of the food were in vain. It showed me how vulnerable and reliant I was on them. All I had caught by the end of the day was one small fish, an average sized shrimp and a crab the size of my finger nail.

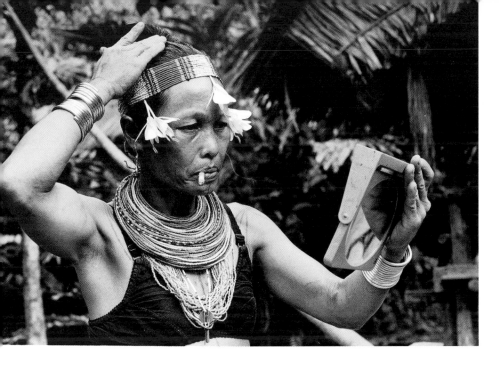

Outings to friends houses were regular, but one occasion felt different to others. Tatani was going to great lengths to prepare herself. I assumed we were going to some sort of ceremony. Necklaces were placed about her neck and waist, her hair was tied neatly on her head and flowers placed precisely in her colourful headband. Handed a bundle of bedding and mats, we set off up the river. I had an overriding sense of excitement by not knowing where we were going.

The house we arrived at up the river was full of strangers who welcomed me with hugs. A young mother sat silently with her two small babies, one of whom had a dangerously high temperature. It was obvious by now I was attending a ceremony to free the child's fever. My cigarettes were greatly appreciated by all and the atmosphere was high, chatting and joking filled the house despite the seriousness of the situation. Without warning the medicine men decorated in flowers and ceremonial beads, appeared silently out of the jungle. Preparations immediately began for the healing. A mixture of sugar cane and flowers were crushed into a liquid and dropped onto the mother's breast while the sick baby suckled.

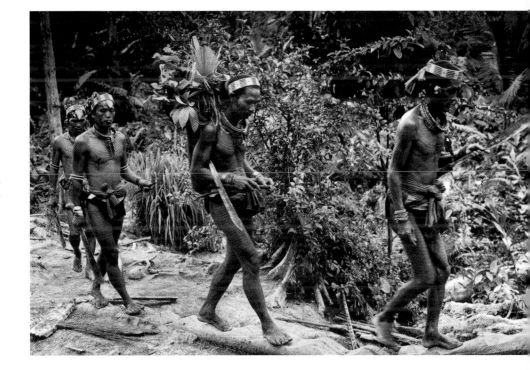

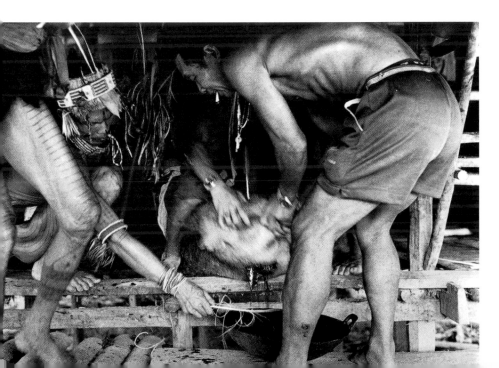

With hooves bound together one huge pig was about to meet its doom. Squealing in frustration, the painful pitch was disturbing to listen to, but ignored by the other women who were engrossed in conversation. The animal was laid on its side with its head over a bowl and speared through the neck. I found it hard to control my facial expressions as the blood gushed from its wound. Its gasping gurgles seemed to last an eternity, but eventually the animal was drained of life.

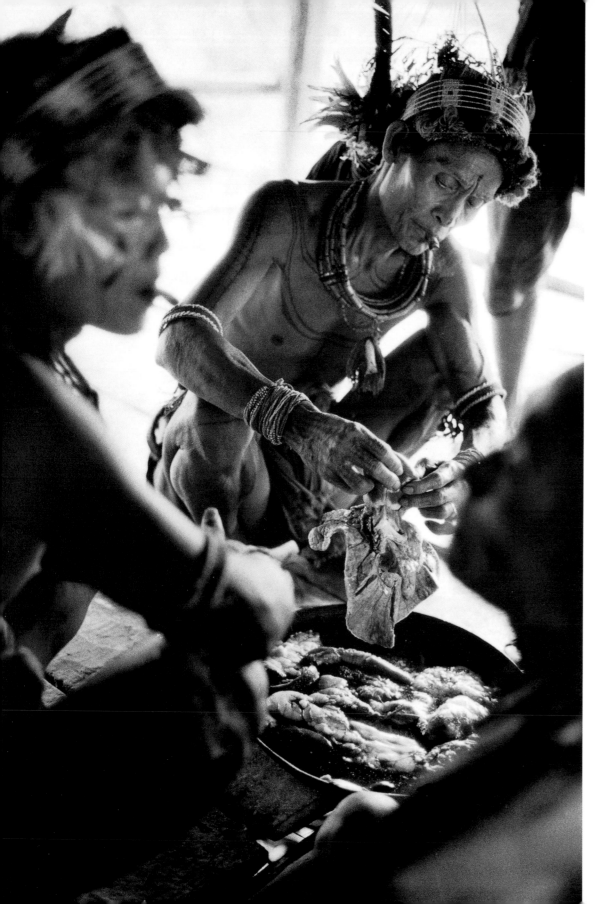

The dead animal's hind legs were held apart and its guts sliced open. Intrigued but disgusted I watched as the intestine blew up and unraveled before my eyes. The heart was then ripped out and studied by the medicine men for some minutes. The future was good, it was revealed later. I just hoped that the baby would get better and there would be no more sacrifice. A feast of boiled pig followed, divided evenly between the group. The revolting smell curbed my hunger pains, giving me time to take in what was actually happening around me. I felt completely useless and unable to help, but at the same time was honoured to be there and witness such an event.

I could hardly believe I was here; this was not a tourist show, it was real life. The drums beat and the excitement rose. A woman in front of me shook uncontrollably as the circle of tribesman spun around faster and faster, pounding the floorboards with their thundering footsteps. The powerful scene in front of me climaxed, the drums suddenly stopped and the circle of tranced-out men collapsed to the floor. With short interludes to catch their breath, the dancing and singing continued throughout the night. Similiar rituals continued over the next two days until the baby's fever broke. Everyone then left and returned to their everyday lives.

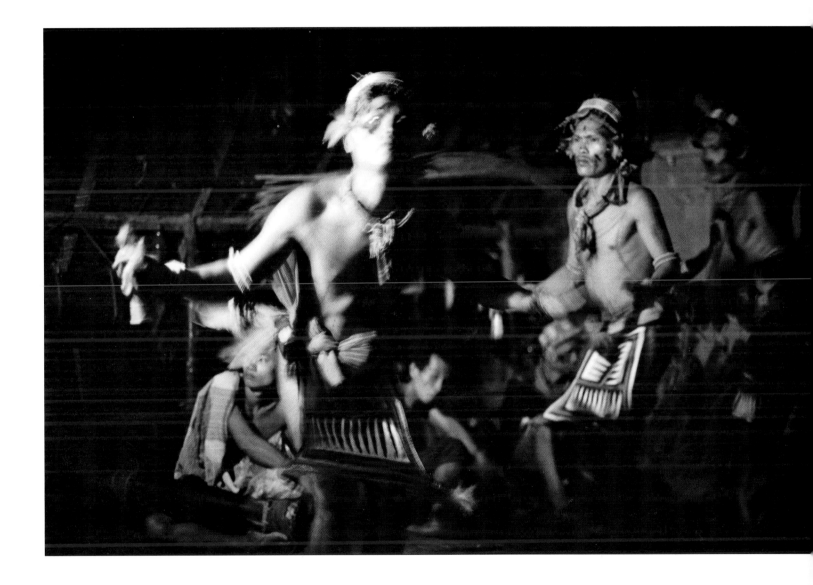

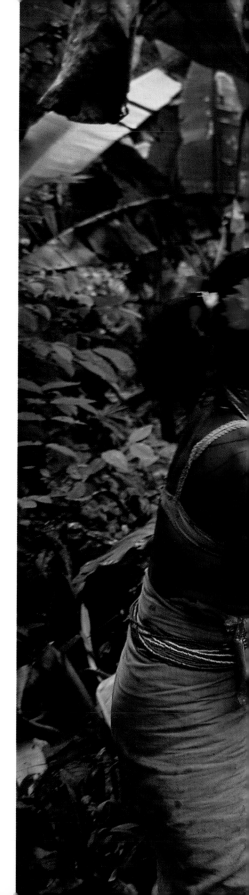

Gossip was a large part of their lives, keeping them amused, as well as me. Unable to keep up with the fast banter I was unintentionally left out of conversations. But by watching them take place, I began to understand the content from their expressions and body language. Their endearing way of finishing off and repeating each others sentences, with added exaggerations, often made me laugh.

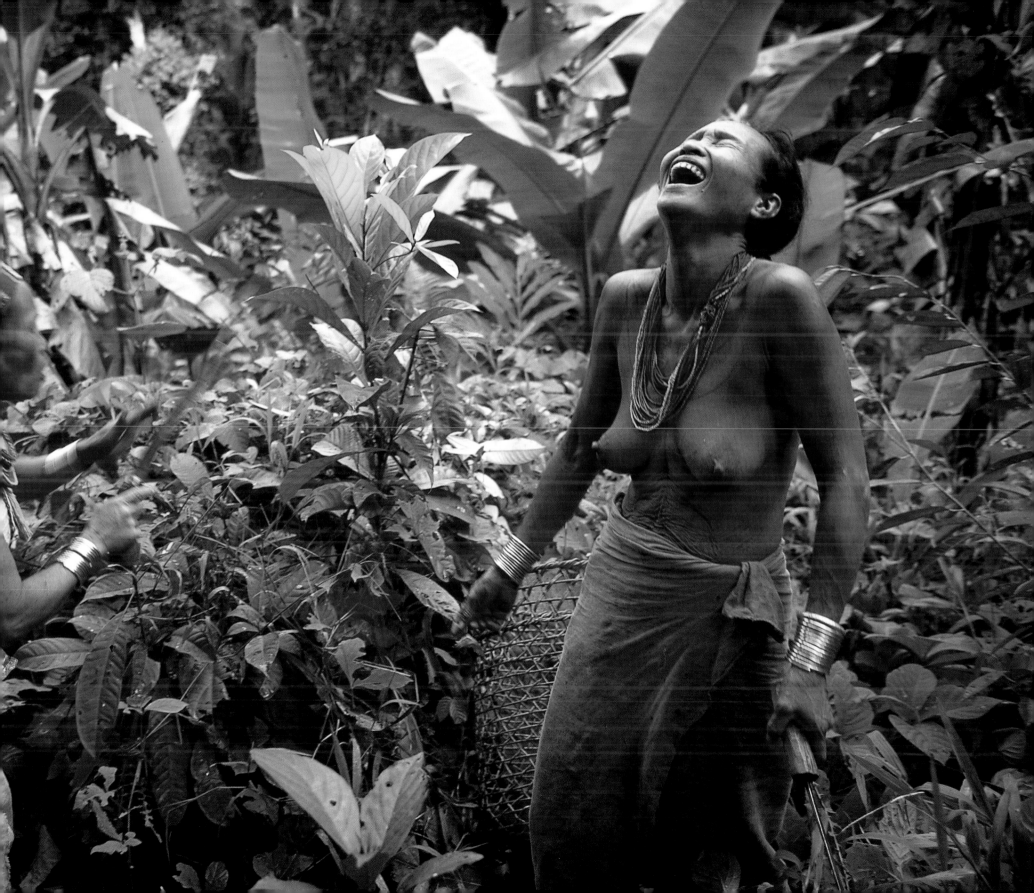

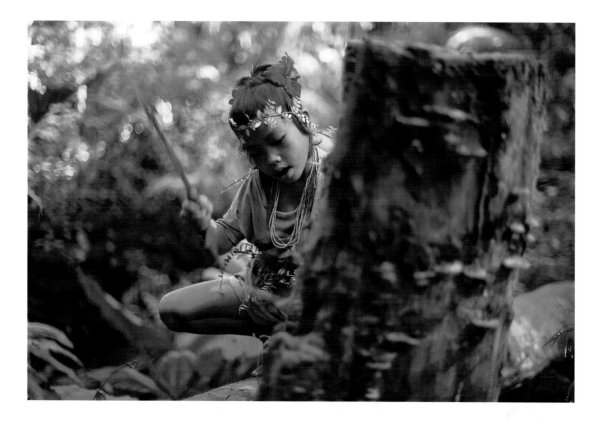

Sleepless nights were regular. The snores, squeals and grunts from the pigs sleeping below and a resident rodent scurrying around the roof often kept me awake. Mornings began with a chorus of cockerels around 5am. There were no lie-ins, work had to be done. Fetching water from the river and washing the dishes was our first chore. Sand and coconut husks replaced detergents and scourers. Mother nature provided everything that was needed to survive. The only luxuries, like cigerettes, rice, biscuits and tea, were bought from the government village, three hours hard walk away. Living like a jungle girl, I often felt like one of them. The detachment from everything I had ever known made me appreciate the many things I had taken for granted in the past. We returned with the water to the house for breakfast, collecting flowers and vines along the way to decorate our hair, and picking ferns and mushrooms to accompany the fresh fish, caught the night before.

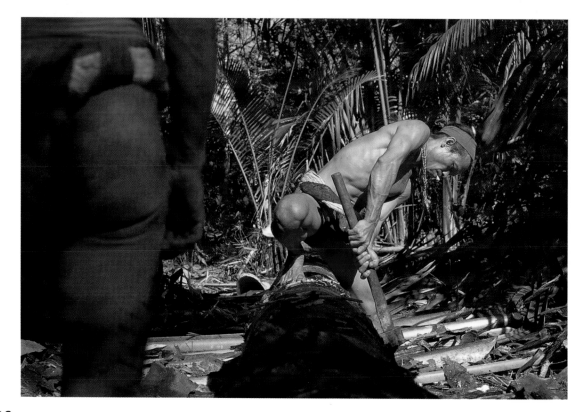

The family had not only their own mouths to feed, but those in their farmyard. The men carried out the hard labour, which included felling palm trees to feed the animals and transporting the logs, but many times the whole family got involved. Carrying the logs to the house often miles away was no easy chore and done in all weathers. I almost passed out with the weight on my back, a similar experience to putting on my rucksack for the first time. Thin vines were used to carry them which ripped into my shoulders, cutting off my circulation. Wading through streams, crossing log bridges and struggling in mud up to my knees, carrying a pig's dinner, wasn't my usual idea of fun, but I was loving it.

Invited for dinner at a relations house, we arrived to a welcome of local greetings and hugs and sat down to an already cooked meal of boiled chicken. An old blind women sat in a corner busily preparing sago which was our staple diet as well as the pigs and chickens. The flour, which was ground down from the insides of palm trees, was wrapped in leaves and baked over the fire. The result was a gluey type of bread stick which accompanied every meal. It would have been embarrassing to have to explain that I didn't eat meat for the hundredth time, but my family had already explained and I was handed a plate of shrimps. Fourteen of us crowded into the tiny room, and it was a fight to eat our food in competition with four dogs, three cats, half a dozen chickens and countless insects running around our plates. They were more than happy to eat it for us!

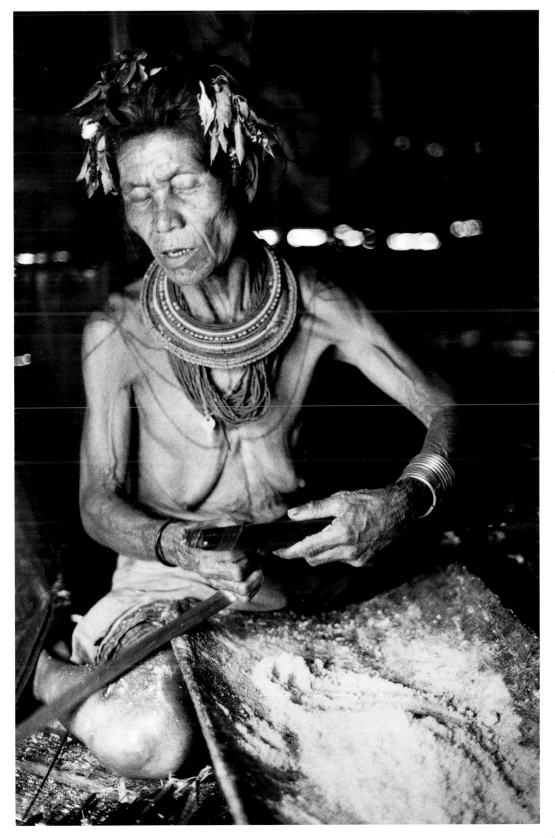

These gentle jungle folk had a
wonderful sense of humour. Their
appearance of chiseled teeth,
tattoos and plucked eyebrows were
merely for aesthetic reasons and
traditions. While appreciating the
surroundings and company I was in,
my thoughts were everywhere - full
of plans, fantasies and feelings. By
day 24, I was beginning to wonder
when my guide would return to pick
me up. I had woken up that morning
and because of a dream I decided
to return home rather than go to
Australia, which meant changing
my plans once more.

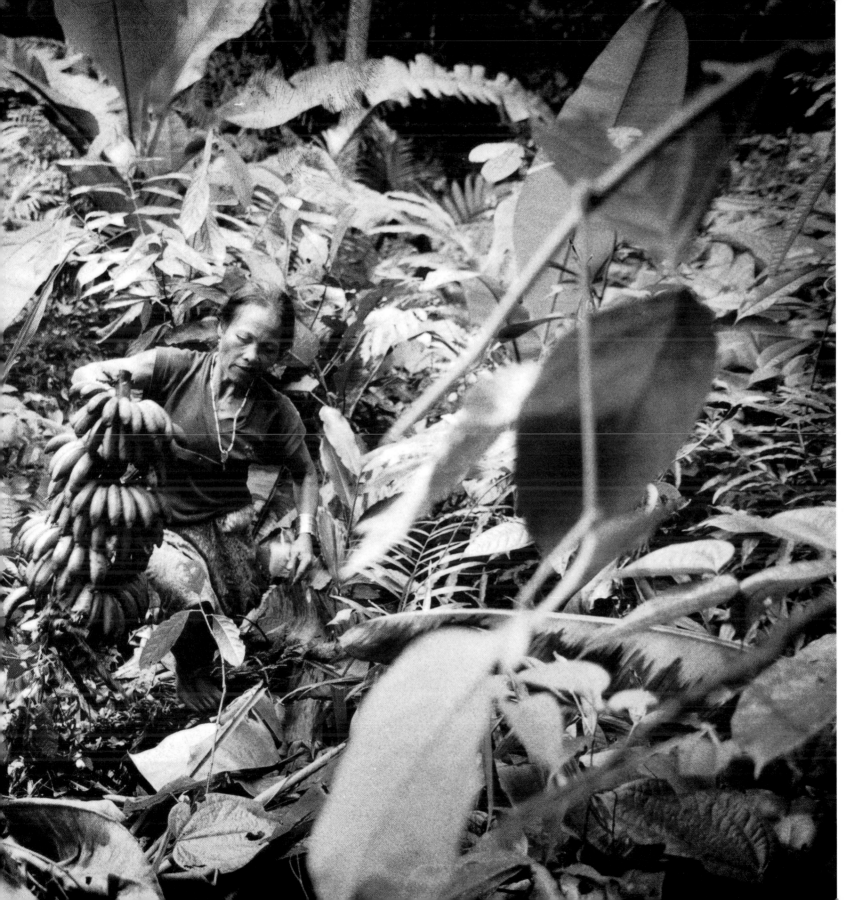

Friends dropped by unannounced from near and far. The bushes would shake and they would suddenly appear. Every house was an open house and the banana stocks were rapidly decreasing as the visitors helped themselves. Regular supplies had to be fetched from the plantation. I was more than happy to do the carrying, not only to keep fit but to play my part. Somehow my fear of spiders, snakes and other creepy crawlies hidden in the undergrowth, disappeared. Although I never did any real damage to myself, it was impossible to avoid scratching my legs to shreds and on one outing I picked up four blood sucking leeches. One of which managed to climb up my thigh un-noticed and sink its teeth into my - a little too close for comfort!

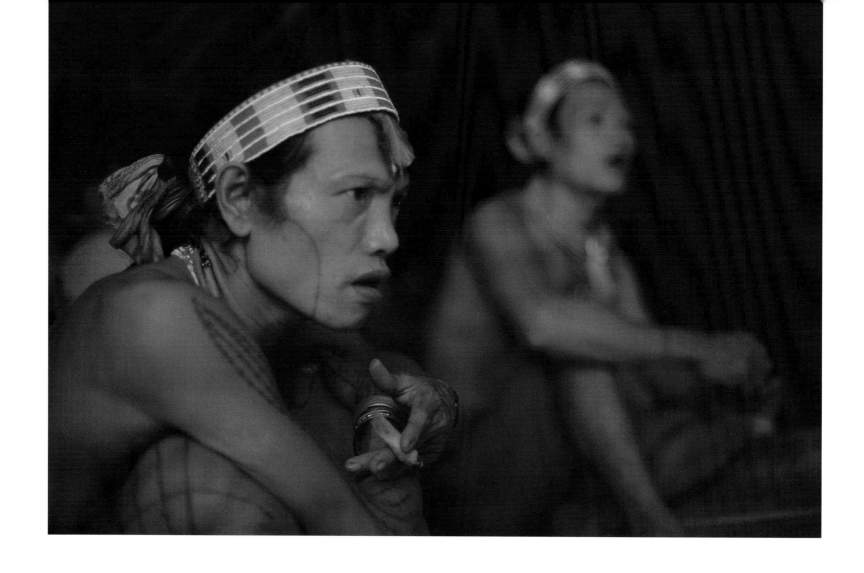

Singing was a major part of their lives, whether for relaxation, entertainment or just for good feeling. Some evenings medicine men would drop by the house; songs and sacrifice would follow. On other evenings, the family would sit together under the stars and sing by candle light, with the Milky Way above us and fireflies all around, twinkling in the bushes. Using songs as a tool to pick up the language, I managed to expand my vocabulary and communicate more easily. Translating the song 'Head, Shoulders Knees and Toes' into their language not only helped me to learn the parts of the body, but it kept them amused for days.

While daydreaming of going home and listening to the sounds of the jungle and kids playing in the distance, I was startled by an unexpected familiar face appearing in front of me. Realising he was my chaperone, I could hardly contain my excitement. During packing, the family hung over my shoulder, eager to accept anything I could leave behind. We sang together for the last time and a moving scene followed as we said our farewells. We left swiftly on our six hour trek to meet up with the group, our last good-byes echoing through the trees. As I eagerly skipped through the jungle, my chaperone fell behind, stopping to catch his breath.

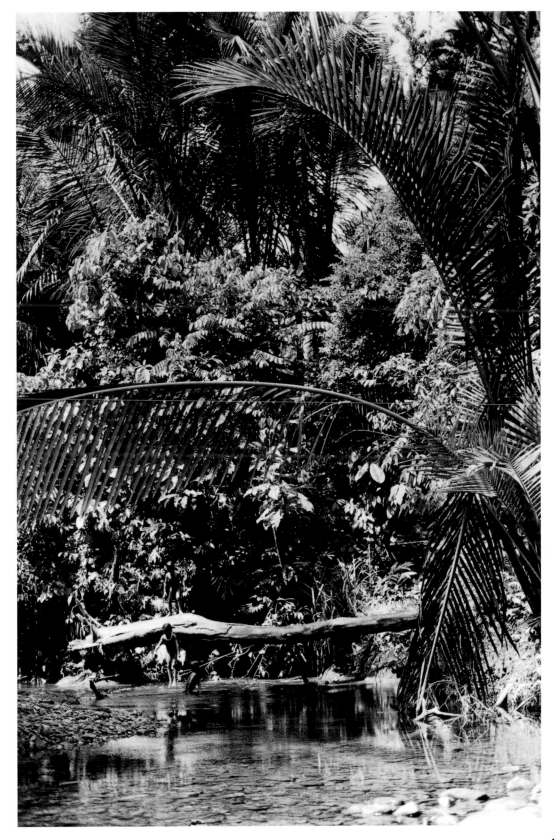

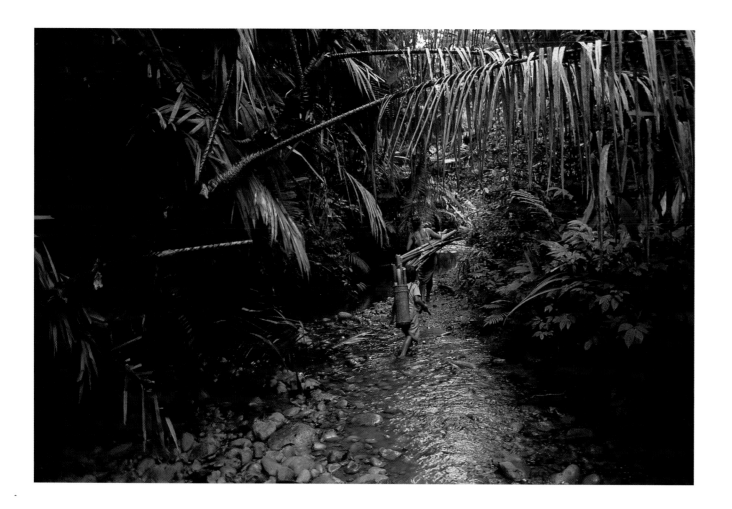

My experience was something that I will never forget. I was accepted into a family's life for six weeks, and taught the basics of survival through their routine chores. Exposed to the wealth of treasures the jungle has to offer and separated from material things, it was so much more than just another tale to recall in the future. Maybe my actions were selfish, wanting to experience someone else's life. They were happy carrying on with their lives, but my influence, and that of others before me had given them an expectation of wanting something more. As much as tourism had made their lives easier in monetary ways, it had also damaged them beyond repair. Shoes had no place in the jungle, but they wanted them. Watches had no value, but they thought they needed them now.

Wading through rivers and streams at a record pace, my feet became bruised from the stones, my legs ached and I wanted to stop, but we had to keep going, as we had to meet up with my guide before dark. We had been protected from the scorching sun under the canopy of the trees, but as the day faded away our trail became dim. Fortunately we reached the rendezvous hamlet before sunset. I could hardly contain my feelings as we arrived. The relief washed away, I had never been so happy to see a bunch of strangers. During dinner, I recalled a few choice stories; it was strange enough talking, let alone tasting Western food. My taste buds exploded on impact.

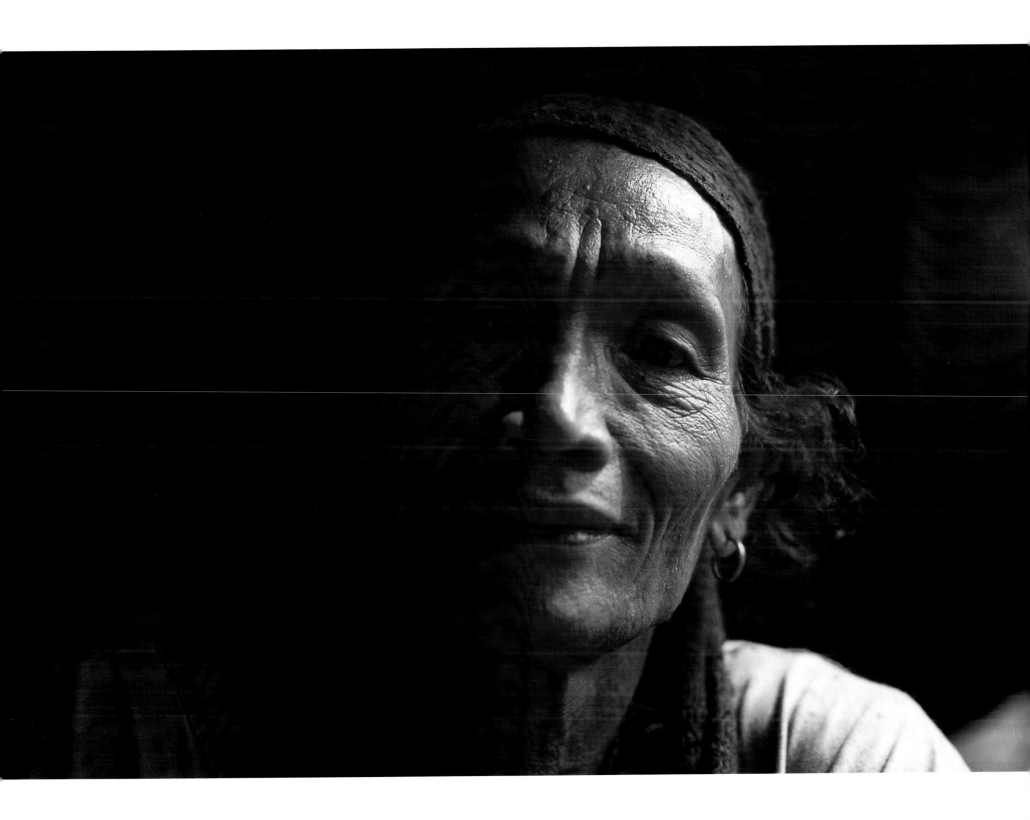

Nepal India
Going Home

After a hectic two weeks of making my way from Samartra, through Singapore and Malaysia, to catch a flight from Bangkok, I arrived in Kathmandu. Now in the final chapter of my trip, time was running out. Throughout my travels, I had taken each day as it came without thinking too far ahead. But since booking my flight home, time was at the forefront of my thoughts and my mind was focused on the day I would have to leave. " Oh no, only thirty days to go!"

It was a great feeling being back in this part of the world, the familiar smells came flooding back. Everything about the place made me feel like I had just walked onto a film set. I was instantly back in the movies. It was strange because I hadn't felt this sensation in any other country I had visited in South East Asia.

Because of time I decided to cut my visit short. I left Nepal with a feeling of unfinished business. As much as Kathmandu had to offer I knew that there was more beyond its boundaries. I was excited to get back into India, but knew that the small taste I had of Nepal gave me a hunger for more. I know I'll go back!

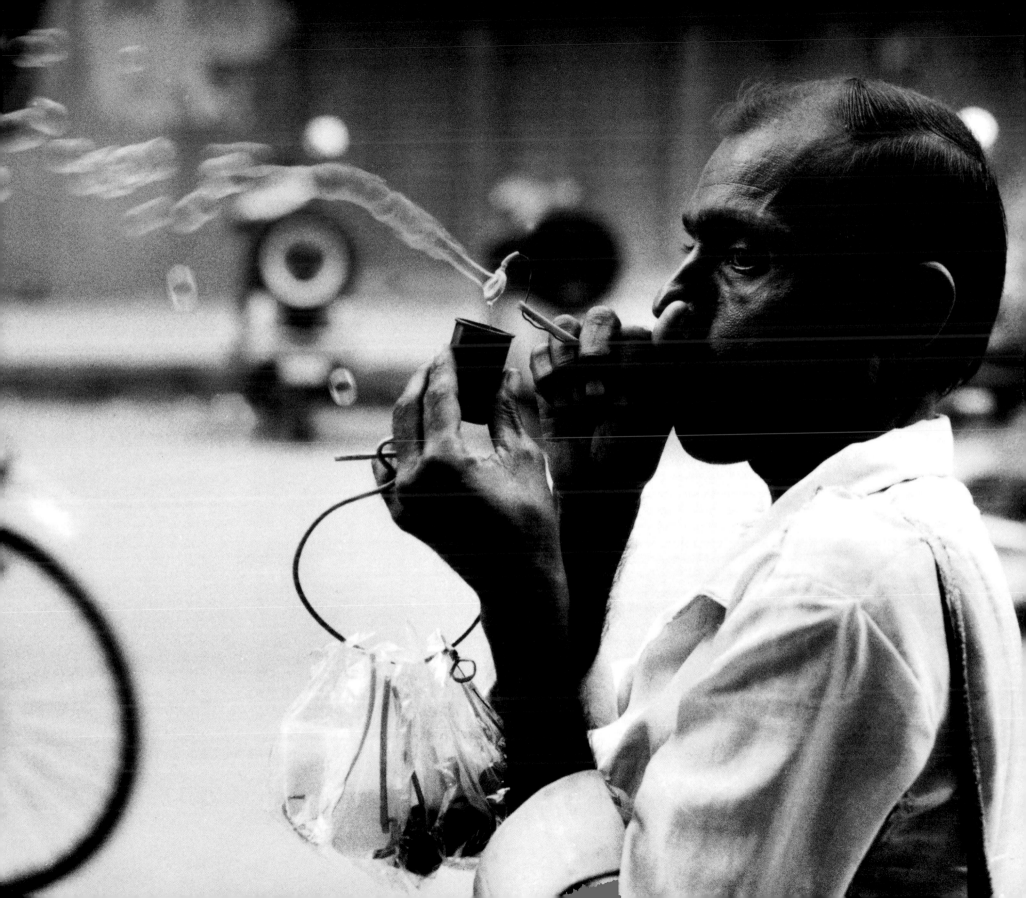

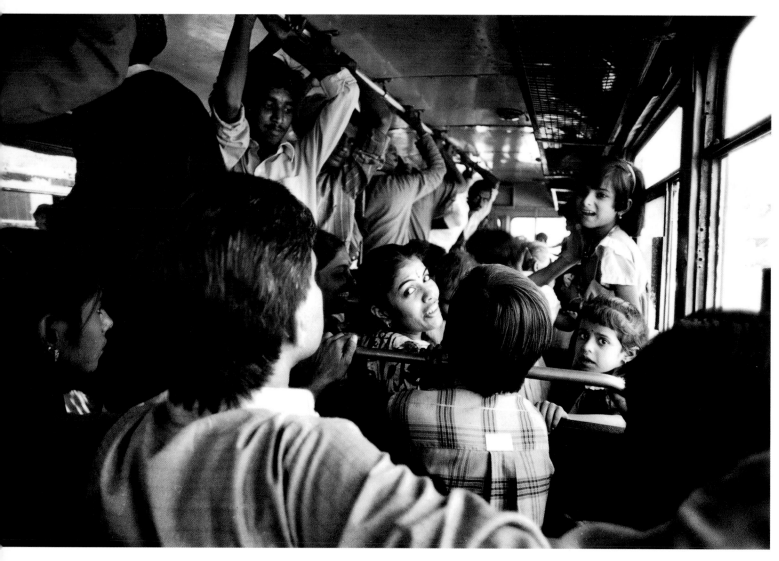

Bus journeys - whether they are mad, bad, or boring, they usually hold a tale or two. Fighting your way onto a bus is the first obstacle. It's first come first served and not at all unusual to see people diving through windows to get a seat. Livestock and produce are also transported filling up the gangways.

I was told a tale by a fellow traveller which summed up the nightmare of travelling by bus: On his horrific journey the driver was drunk and driving like a lunatic with a death wish. About half way through the fifteen hour journey, an Indian passenger stuck his head out of the window. Unfortunately for him an oncoming bus was passing closely in the opposite direction, and took his head clean off. The bus carried on despite this and the passengers had to sit for eight hours with a headless corpse behind them!

The mile-long train heaved itself into motion, chai and coffee wallahs, food vendors and beggars sang their last song on the platform of Gorakhpur station and we headed towards Calcutta. The echoes and confusion were left behind in a blur through the barred windows. Inside the train, my sleeper carriage was surprisingly empty, apart from a few off-duty officers who were always good for security, even if they were asleep.

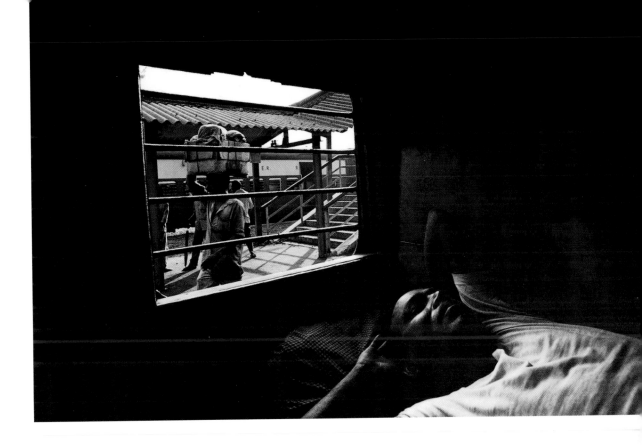

Slowly the buildings of the city disappeared, along with its pollution and intense heat. They were replaced by flat open plains and fresh air. It wasn't long before the train pulled up into a station and the blissfully empty passageways of my carriage were filled up. Chai and coffee wallahs boarded the train along with the passengers, and their deep throated chants flowed through the corridors. The train once again jerked into motion with them all on board.

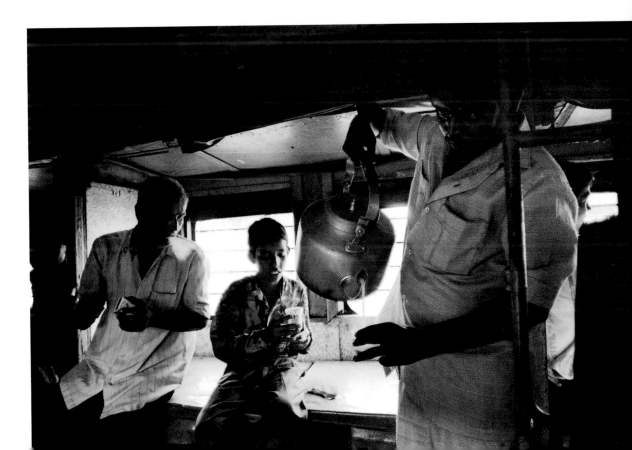

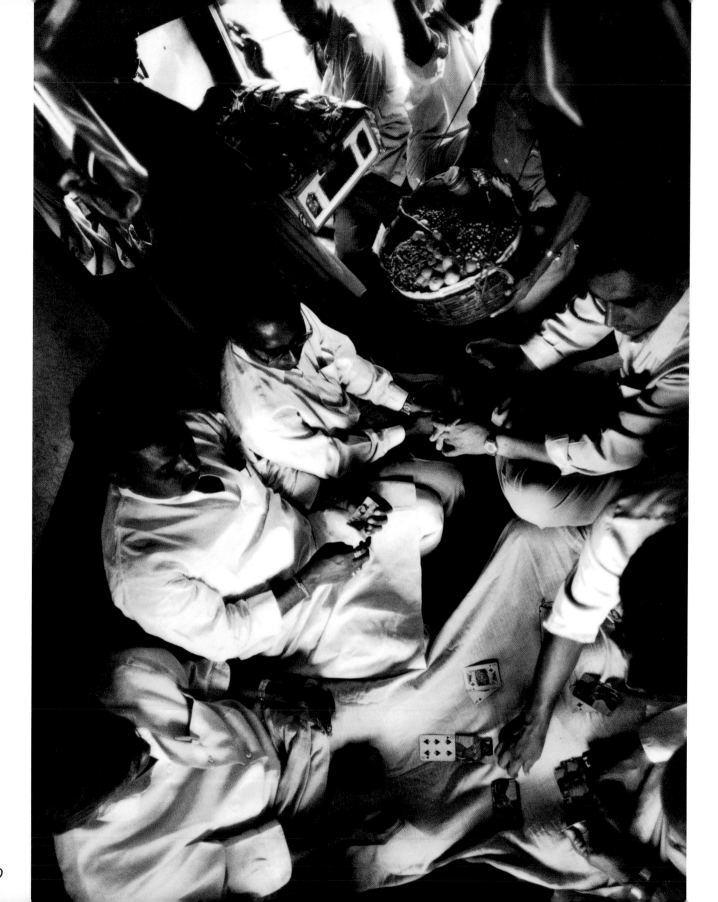

We seemed to be stopping more often than the amount of miles we were covering - even though this was the Express. Just as I thought that the carriage was full, another hundred or so commuters boarded. The intense neglect of respect for each others space became unbearable. Luckily I was able to escape to a top bunk, where I hid with my bags for pillows untill morning.

The carriage was awoken at sunrise by the cries of the coffee wallahs at a station. Most passengers got off and made a quick dive for the washing facilities to freshen up. I nervously got off the train not knowing how long it would stop for, and bought a breakfast snack, which was handed to me in an eco friendly leaf plate. Despite the mornings activities some passengers still managed to sleep undisturbed!

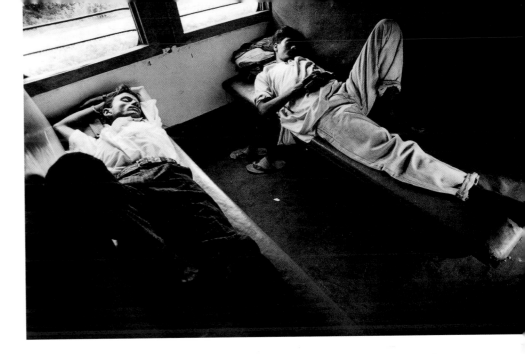

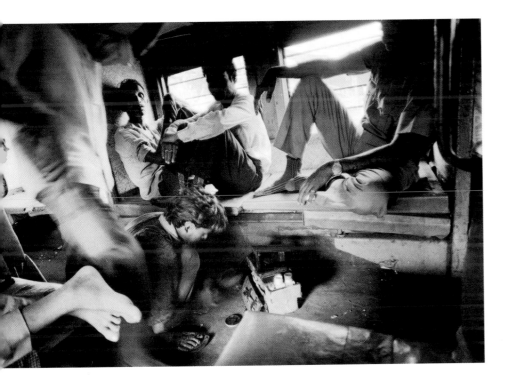

As the train set off, vendors of all descriptions boarded with us for the ride. Samosas, chapattis, curry, peanuts, coconuts, newspapers, cigarettes, sweets, biscuits and bananas were just a few offerings that flowed through the carriage together with the variety of smells. Not to mention the floor sweeper, the shoe shiner and the blind beggar who sang a sweet ballad to the chimes of his tiny cymbals.

As the chaos in the carriage subsided, my attention was drawn outside. The track ran parallel to a road, and a number of buses passed by with as many passengers on top as inside. We passed small clusters of mud huts, where a group of kids waved at the train as we whizzed past them, their cries drowned by the thunder of the train against the uneven tracks.

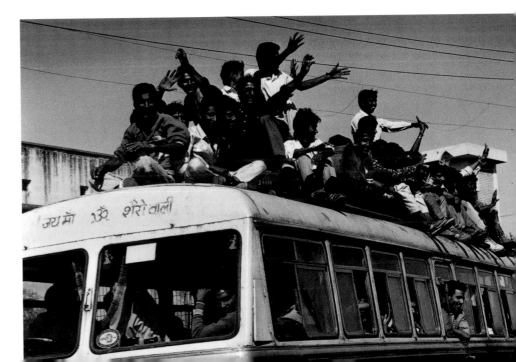

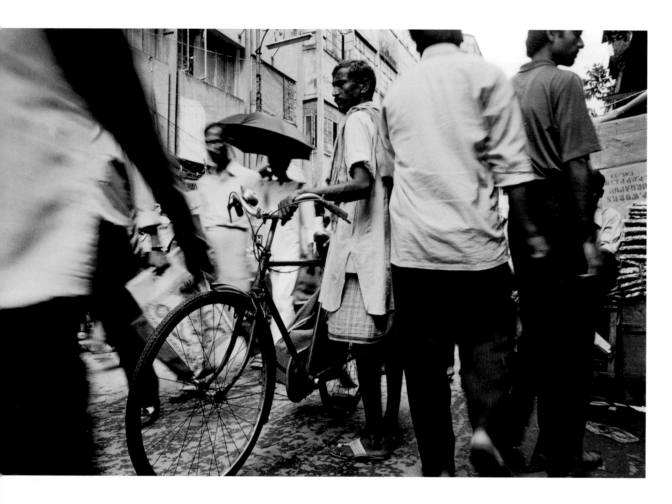

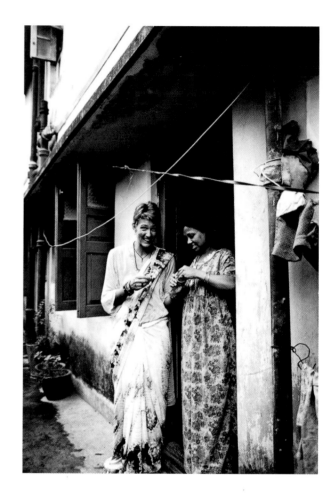

Calcutta was chaotic. Traffic and bodies constantly on the move. Staying with an Indian friend, (whom I had met briefly at Ambala train station almost a year before) I saw little of the city, but felt as if I'd met half its population. During my stay I was introduced to an unending line of brothers, sisters, uncles, aunties, cousins, nephews and nieces.

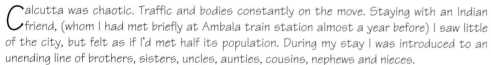

They couldn't understand that I didn't live with my family. For me it was hard to grasp how eight people could live in three small rooms. But it was great to be part of such a close family. Space wasn't important. The mother was suffering from a crippling disease and was unable to do anything for herself. One of her sons had given up a position in the Indian Air Force to be with her. The other had left his studies and taken a job with flexi hours to help look after her. Nothing was more important than family unity and I felt privileged to be part of it. Dressing me up in a sari, they made it quite clear that fat women are more beautiful. I would have to put on a few extra pounds up top to get a decent husband!

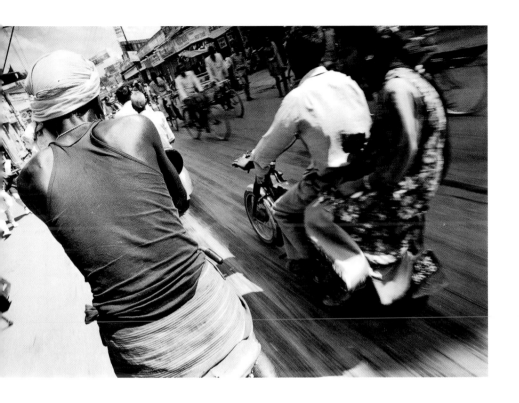

Cycle rickshaws tout for business on every corner. The fun part was bargaining. White skin trebled the price and only by serious haggling and pretending to walk away did the price come down. Having explained the destination and agreed on a price, you invariably ended up in the wrong place. Your chosen destination had either burnt down, flooded, was closed or was full! It was difficult to be angry though having seen them strain under the weight they had been pulling. I had to get off and help one guy who looked as though he was about to have a cardiac arrest.

I got into a conversation with an Indian gentlemen on the subject of poverty. "These poor people," he said, "they are born like animals, they live and die like animals." I was shocked at his harsh statement towards his fellow countrymen. He carried on to describe the life of a rickshaw man. "He doesn't own the bike, he rents it on a shift rota. The money he earns pays for food, tea and rent. On average he will pocket ten to twenty rupees per day. (Fifty Pence.) He either sleeps on his bike, or joins the thousands of other pavement dwellers. There are plenty of spare women, so marriage is very common. The couple pick a pavement suitable to their needs and before you know it, he is supporting a family of three on the same salary. No home, hardly any income, but the security of family and friends in the same situation." On to the subject of Religion he said, "they believe in God, if they didn't they would have nothing to live for. They believe that if they are good in this life then they will be rewarded in the next."

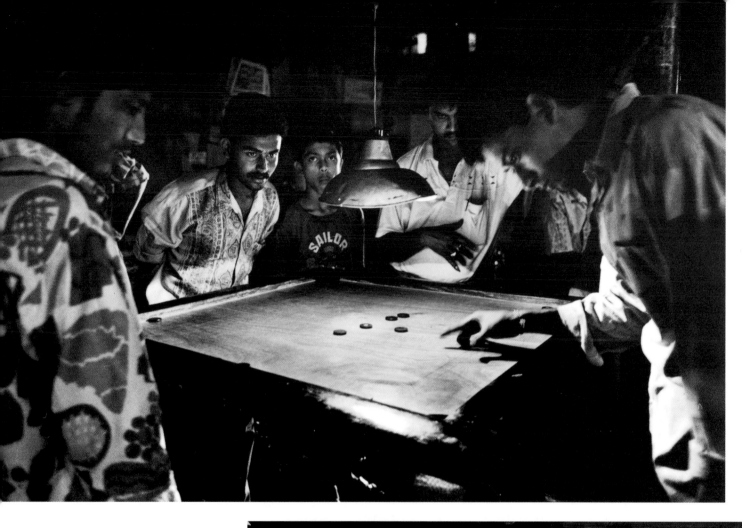

The streets were always busy even at night. Playing Carrom was a popular pastime among the men. Gambling what little money they had, they concentrated hard on the game in hand. Just a short distance from the roadside distractions.

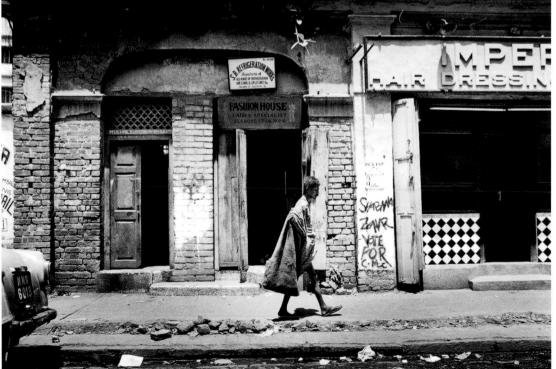

The Indians have their very own system for clearing rubbish. The poor folk recycle what they can, and what is left, the cows eat.

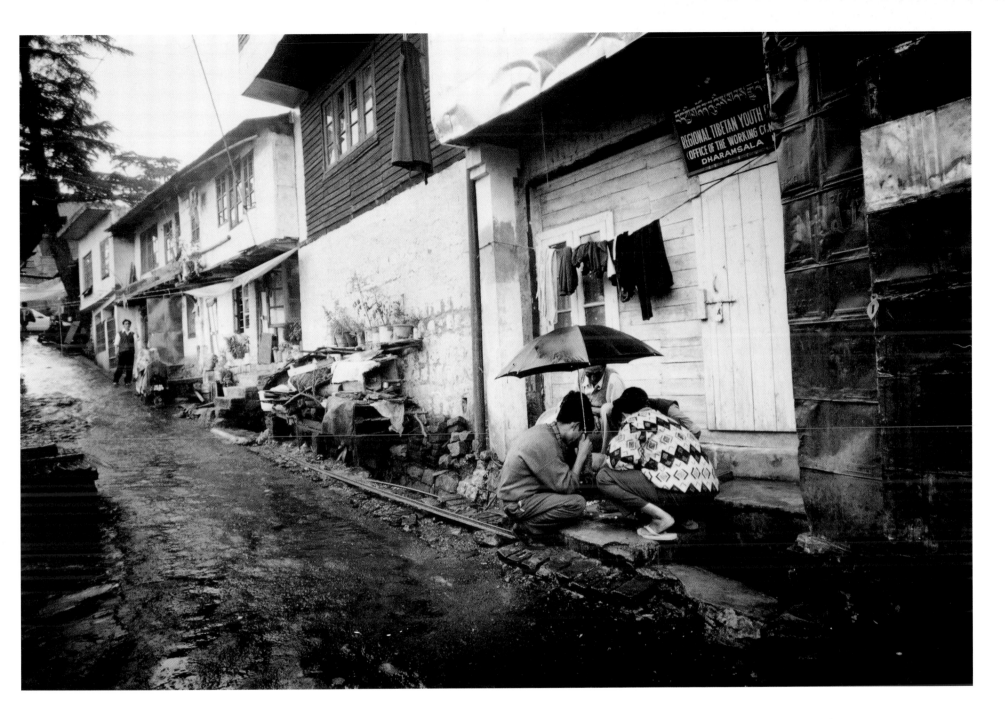

Dharmasala had its own mystique and magic, despite the storm which didn't lift for three days. Trapped in my hotel, made contact with other travellers easy, and many pancakes were consumed over spiritual conversations. The locals were quite used to the weather and carried on regardless with their trading and gambling in the street.

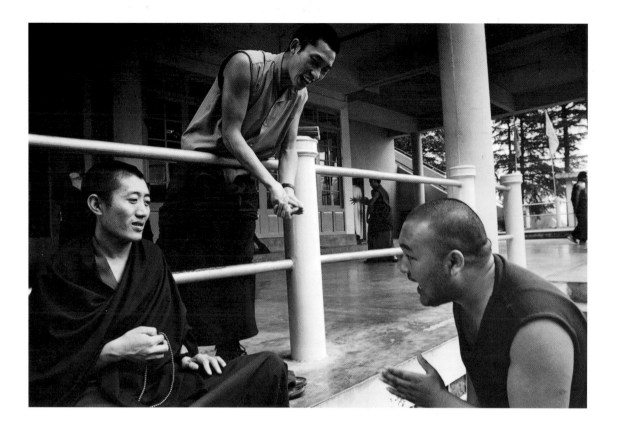

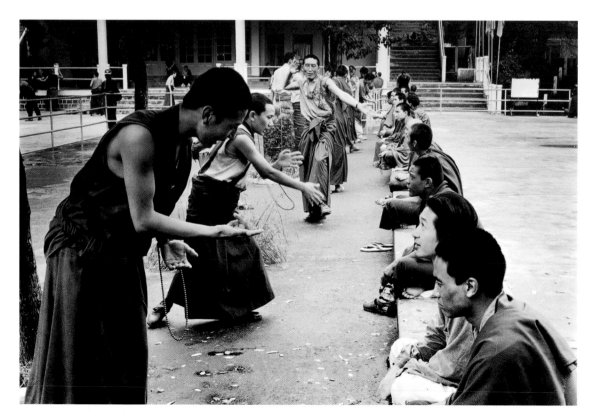

Travelling without a guide book was exciting and somehow fate had brought me here. The rain clouds lifted to reveal the most inspiring views. The lush scenery and uplifting spirits of the local Tibetans erased my worries about going home. The energy was contagious. Every day had a surprise in store. Walking through the peaceful surroundings of Mcloed Gang, the sounds of prayer wheels being turned and chanting attracted us to the Monastery.

From a rough translation, we were able to ascertain that the lively performance of dancing monks was a healthy debate on politics and religion.

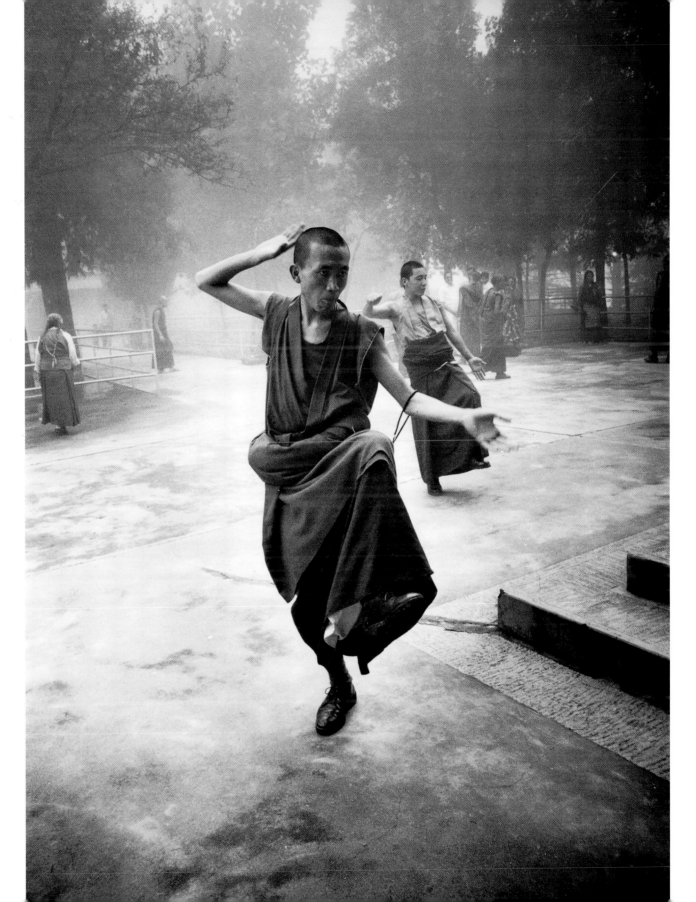

My travels started with the nightmare of my rucksack not turning up, and the outbreak of the plague. They finished with another horror!

The night bus from Dharmasala to Delhi made a stop at a chai stall along the route. Waking up, I went in search of a toilet. Sleep walking I swayed through the cafe to the back yard, in search of a dark corner. Spotting a secluded area, I ducked underneath a fence. Stepping forward my foot sank into a warm moist sludge. Still half asleep, the ground ahead looked firmer in the dim light. Taking another step forward I ended up thigh deep in stinking silage. Only when I delved down to retrieve my sandal, I realised I was sinking. I heaved myself out and returned to the bus in stunned silence, barefoot and dripping in muck. I smelt worse than an open sewer, but it was impossible not to see the funny side of it, as everyone fell about in hysterics. The bus was delayed while I changed, and the conductor insisted my trousers were hung out of the window to air. It was the most disgusting experience of my life!

The bad luck didn't finish there. When I got to Delhi to reconfirm my flight, they had given my seat away. But luckily I managed to talk my way back on. It had been a memorable last few days. Things didn't always go to plan, but looking back, what a laugh!

top travel tips

- Leave your favourite designer clothes at home. Listen to granny when she says you only need three changes of clothes. One on, one in the wash and one spare in case you get caught in a freak monsoon.

- Girls wear a skirt when travelling by train. It's impossible to keep your balance and hold your trousers up, while going to the loo on a moving train.

- Girls wear a wedding ring.

- Obey the dress code in different states and countries. It's best all round if girls cover up and even elbows are considered rude in Indonesia.

- Leave your towel at home - far too bulky, they never dry and what's more a sarong can be many things. A skirt, a scarf, a blanket and a towel.

- Ignore the tourist touts, book all journeys from government approved tourist offices.

- Wear minimal jewellery, they can be ripped out or wanted as gifts.

- The saying is true - The bigger your bag - the more you carry. Limit yourself or you will regret it later.

- Take a padlock and key for double protection. In hotels you can be sure that their key won't fit your lock.

- Take a torch, small is best, a medium size maglite with a good handgrip can always double as protection.

- A travel cushion is essential. Travelling for twelve hours with your head banging against a metal frame is not funny.

- A bike chain or similar to secure your rucksack going walk-about while your sleeping on a train.

- Take postcards of your home town, it fascinates the locals.

- Best of all take along an open mind and plenty of room in your rucksack for nik naks and souvenirs